THE DAY AFTER YESTERDAY

The MIT Press would like to thank the anonymous peer reviewers who provided comments on drafts of this book. The generous work of academic experts is essential for establishing the authority and quality of our publications. We acknowledge with gratitude the contributions of these otherwise uncredited readers.

This book was set in Portrait by Commercial Type.
Printed and bound in the United States of America.

Library of Congress Cataloging-in-Publication Data

Names: Wallace, Joe (Photographer), author.
Title: The day after yesterday : resilience in the face of dementia / photography and text by Joe Wallace.
Description: Cambridge, Massachusetts : The MIT Press, 2023.
Identifiers: LCCN 2022049805 (print) | LCCN 2022049806 (ebook) | ISBN 9780262048606 (hardcover) | ISBN 9780262376488 (epub) | ISBN 9780262376495 (pdf)
Subjects: LCSH: Dementia—Patients—Pictorial works. | Alzheimer's disease—Patients—Pictorial works.
Classification: LCC RC521 .W33 2023 (print) | LCC RC521 (ebook) | DDC 616.8/31—dc23/eng/20230420
LC record available at https://lccn.loc.gov/2022049805
LC ebook record available at https://lccn.loc.gov/2022049806

10 9 8 7 6 5 4 3 2 1

THE DAY AFTER YESTERDAY

Resilience in the Face of Dementia

JOE WALLACE

THE MIT PRESS
CAMBRIDGE, MASSACHUSETTS
LONDON, ENGLAND

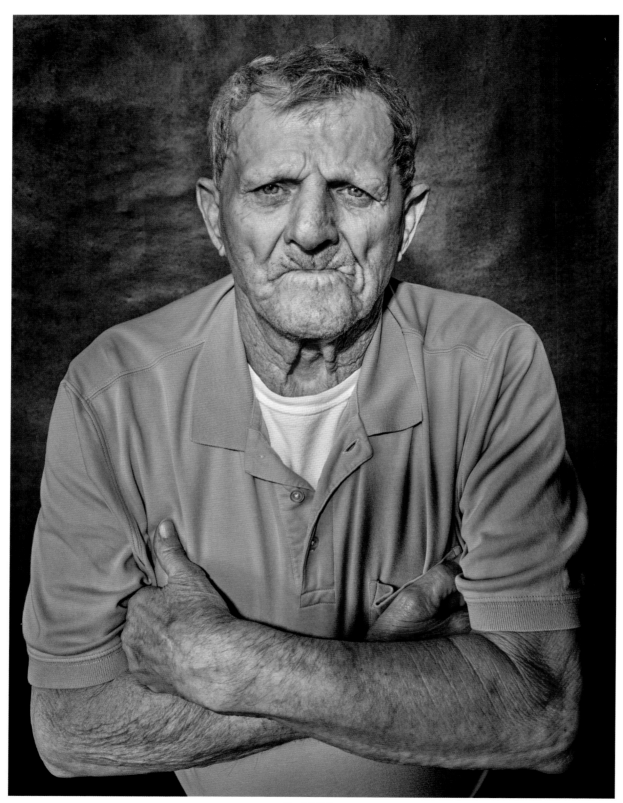

Patrick Brien

147

ENDING ALZHEIMER'S DISEASE IN OUR LIFETIME

by Dr. Rudolph E. Tanzi

154

ACKNOWLEDGMENTS

157

ABOUT THE AUTHOR

PORTRAITS OF DEMENTIA

IN 2023, FIFTY-FIVE MILLION PEOPLE ARE LIVING with dementia globally. In the United States, one in three seniors suffers with Alzheimer's or another dementia at the time of their death. The US government, through Medicare and Medicaid, will spend approximately $345 billion to care for people with Alzheimer's and dementia. In addition, $340 billion worth of care is provided by family members and unpaid caregivers. More than six million people in the United States have been diagnosed with Alzheimer's or another dementia. It's estimated that only one in four people with the disease is diagnosed, which means possibly up to twenty-four million people in the United States are living with dementia.

And yet despite the millions of individuals and families affected, dementia is often a taboo subject with limited public awareness or discourse. A diagnosis can become a mechanism for segregating those affected from society, making it easy to see only the label instead of the individual.

The typical narrative about dementia tends to focus on the clinical diagnosis or medical status of individuals and is all too often depicted using fear, despair, and vulnerability. This narrow and incomplete view of dementia quickly becomes a powerful means for us to distance ourselves from their humanity and does little to change the stigma of those living with the disease. In many ways, highlighting the stereotypical perspectives only makes it easier to continue ignoring the burgeoning health crisis and the individuals themselves.

The goal of this book and the traveling exhibit is to destigmatize those living with dementia, to use empathy as a means of connection and understanding, to tell a more complex and complete story of those living with the disease and its effect on their families and loved ones, and to give the audience courage to act in ways large and small. You must show the whole story: the fear, loss, and despair but also the love, connection, dignity, and powerful humanity that always remain in the subjects, in the care partners, and in the families and communities. That is the only path to evolve the narrative and have a positive social change.

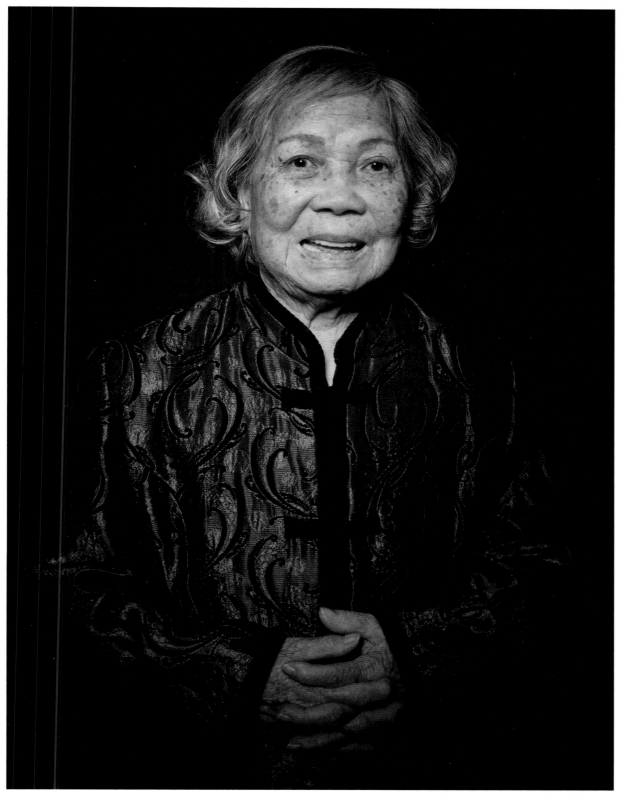

Pho Thi Ngo

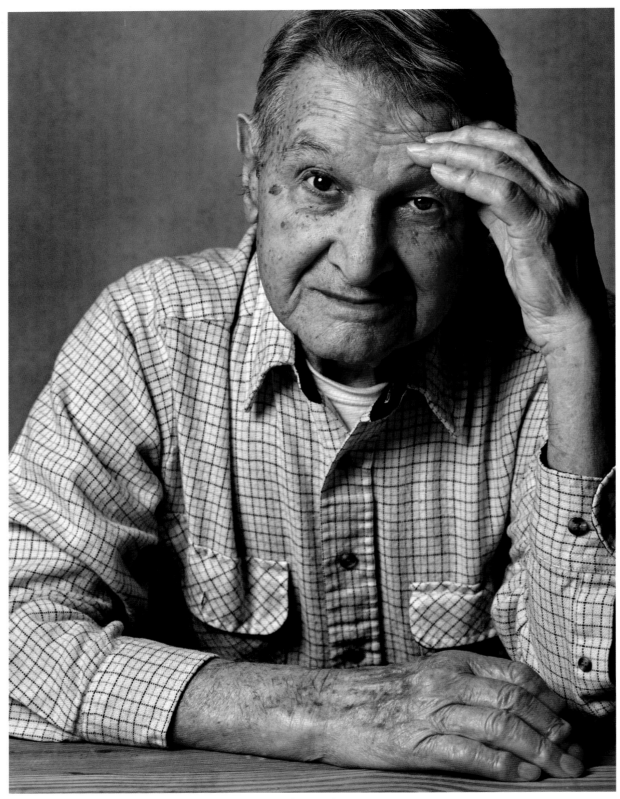

Edwin Bartlett

A CONVERSATION BETWEEN DAVID SHENK AND JOE WALLACE

I WAS LUCKY ENOUGH TO BE INTRODUCED TO Joe Wallace's powerful work in 2021. His collection of portraits and stories has been touring the United States and shaking things up in the dementia community since 2017. There's something very special going on here.

Speaking with Joe, I was even more moved. The brutality of Alzheimer's brings out the worst in some and the very best in others. In Joe's case, his family experience with dementia seemed to awaken a profound curiosity and sense of mission. He felt the call—and has truly answered it.

Assembling his work into this beautiful book was the obvious next step, and I was honored to be asked to contribute an introduction. After speaking several times over the internet during the pandemic—about where this grand project came from, what he's hoping to achieve, and where he goes from here—we decided the best way to convey both of our thoughts would be to transcribe our conversation.

DAVID SHENK Let's put this conversation in a physical place for your readers. I'm in my home office in rural western Massachusetts. Where are you?

JOE WALLACE I'm on the other side of the state, in my attic studio above my garage in my home in Carlisle, Massachusetts—about twenty miles west of Boston.

DS So, tell me, how did you first get into this project?

JW Like millions of other people, I have a deep family history. My grandfather, Joe—who I'm named after—was diagnosed with Alzheimer's when I was in my late twenties. Many years later, long after his death, my grandmother Bebe—Joe's wife—also developed dementia.

Granddaddy Joe was my childhood hero. They lived in Birmingham, Alabama. When he had a heart attack, we also discovered that he'd been hiding his cognitive decline from his wife and his neighbors. That was the first time I heard the term

"Alzheimer's." My mother and grandmother had to run some errands one day, and said to me, "Okay, you stay with Granddaddy, we'll be back." And I remember being so frightened to be left alone with him. I didn't know how to act, think, talk. So, we just started talking, and we ended up having one of the most memorable days we ever had together. He could hold an audience for hours telling stories of his youth growing up on a farm, building roads in the swamps of Georgia—all these amazing stories—putting himself through college. He was a Golden Gloves boxer. We just had this magical day. As long as we kept to the things that he cared about, we were fine.

When Bebe started experiencing dementia years later, I would visit her, and, again, I remember feeling uncomfortable at first. I was disquieted by the place and wondering, How is this going to go? What do I say? How do I act? How do I be present? I would always have a lovely visit with Bebe— and I began to meet other people, other residents, and other family members. People would start sharing these wonderful stories. It was this whole world that had been hidden from view. I observed a pattern: I always feared one thing, but once I could be present, there was this whole new world of experiences that were happening inside the nursing home. It was sort of this secret club that nobody really wanted to be a part of.

DS You were breaking through the stigma.

JW Exactly. I met people that were really loving, clever, funny. I met some really interesting people and felt lucky to know them.

One day, I was talking with my parents about these incredible interactions you can have in those circumstances—because it's so real. There's no BS. You're there. It's hard, but also wonderful. People are trying to focus on the good as opposed to the despair, and it brings out this vulnerability in people. I was talking about all this, and I just had

a moment—a realization that we could all do so much better. There is so much to be gained by trying to share the good parts that I was coming away with—to absorb the humanity and the commonalities between people. The connection, the love, the hope.

DS This realization of yours happened about ten years ago?

JW About that. I was thinking about these experiences as my grandmother was dying, and I started working on the project a few years after she was gone.

DS And by this point, you had become a professional photographer?

JW Yes. At the time, I did a little bit of commercial photography for a wide mix of corporate clients. I hadn't done much fine art, other than for my own pleasure.

DS And at some point, you shifted to this art project and put your commercial career on hold more or less?

JW Exactly. I put my camera down as a money-making endeavor and only worked on stuff that I was really interested in or passionate about. As soon as I started working on this, I knew it was going to be important to me, that it was decidedly real and impactful, even if nobody ever saw it.

DS That is the mark of a truly great project: when you want people to see it, but you're completely committed even if no one ever sees it.

JW Yes.

DS I'm guessing that you began in a familiar place.

JW Yes, the first place I photographed was Bebe's last nursing home. I photographed a bunch of families there. That first day, I think I photographed and interviewed three different people, and it felt really good. It felt like I was onto something.

DS How did you choose the approach and the format?

JW I let the style and tone flow from the project objective. I wanted something that was the very antithesis of the stigma that I wanted to bust through. I felt like the public narrative was all about fear and despair and that most images being made about dementia were exploitative of that. Those images made you look away. They made you feel that everything was futile.

DS If I'm hearing you right, your main thrust from the beginning of this project was to show a more well-rounded, real person behind the cartoon of the disease. We can try several different ways to say that, but does that gel with what you're saying?

JW Yes. I wanted people to see a more complete picture, to use empathy as a way for someone to want to know more about the person. I wanted to show that there's a value in making a connection and paying attention. There's a dignity in that human exchange, especially with someone in a stigmatized and ignored group. Shame on me that I had previously assumed that I would have nothing in common with many of these people, and that interacting with them would be a total waste of time. Once I started doing this, I no longer had that feeling with a single person I photographed. I met some people that I liked and some people that I didn't like at all, but even those people had important experiences to learn from.

DS And I understand that you wanted this to be a public project but was there also a feeling that you wanted to show this "real person" to their own family—or back to themselves? Was there a more intimate goal as well?

JW That's a great question because as you're interviewing somebody, you experience it on several different levels at once. How does this apply to the narrative of this particular individual? How does it apply to the narrative of this particular family? How does it apply to the narrative of the larger societal health crisis?

DS And you just try to navigate that intuitively?

JW Exactly. I have to be careful because I try not to editorialize about what I'm hearing, but I do think like a social worker or a therapist. Sometimes I'm trying to get people to reflect on how they're feeling in that moment. Other times, I might want to challenge the person to think differently about something.

DS How did the process evolve?

JW I got better at it, I think, over time.

It took me a while to get over tiptoeing through sensitive areas and to just be me and to ask my questions, to realize people with dementia are just people, and they want to laugh. They want to cry. They want to be challenged. If they didn't want bullshit before, they don't want bullshit now. Most people don't want to be treated like they're sick or they're dying, and if they like dirty jokes, they want to hear a dirty joke. I think that a lot of people who have dementia feel ignored and marginalized. I realized that sometimes hard questions can be a gift. The digging-in is caring.

DS That's a powerful realization.

JW It was, and it has affected the way I communicate with people in all aspects of my life. I've always been a pretty forthright, no-bullshit kind of person, but now I'm even more direct and honest.

DS I must say, I'm not surprised at all to hear that you feel your life has improved as a result of these conversations. When I entered this world many years ago, I found it so rich—because of the dementia. People just tend to talk much more about what's real and important. It's a beautiful thing and can make a lot of other aspects of your

life seem pretty trivial. Yes, it's sad, but it's also meaningful. You come out of these interactions inspired. You feel alive.

JW I'm so glad to hear you say that because, as you say, all the other shit can fall away, and you can have these really incredibly meaningful and powerful moments. That's what I'm trying to share with this project.

DS If there is a point of life—I'm not sure there is—but if there is an actual meaning of life, what is that meaning? It can't possibly be the bullshit. It can't possibly be the small talk at a cocktail party or the toys you can buy. It just can't be.

JW I've interviewed about sixty-people so far. Nobody talks about success; no one talks about how much money they made, their fancy house, their car—no one. People talk about their families. They talk about holding hands on the beach or something their grandmother just told them. It's these very real experiences. I find that so beautiful and so impactful on my own life.

DS Here's what I don't quite understand about your story so far. I get the personal motivation behind your project. But I don't quite get where the journalistic/social activist motivation came from. You seemed to suddenly leap from being a commercial photographer to an artist with a public conscience.

JW It wasn't sudden. Both my grandparents were dead before I even started. In a certain way, you could say I sat on my hands for a long time.

There is an arc to my photographic career, which is a search for meaning. As I got into my forties, I wanted to do something that mattered. A lot of commercial photography is creatively satisfying, but the net product is a little vacuous sometimes.

DS You're selling stuff.

JW Yes. Pretty pictures look great, but it can feel kind of empty. And I did have a degree in journalism, and I started to think, "If these experiences mean something to me, they might also mean something to someone else." I thought, "This might fail, but the idea is sound."

DS So how did you come up with the precise format? Was it right at the beginning that you would do portraits and interviews in this way?

JW Based on my experience of being with my grandparents, I knew that the stories, honestly, would be more important than the picture. The pictures had to be good enough to get people to read the story because the story was where the real connection was going to happen.

DS What's your approach? Photograph first or interview first?

JW It totally depends on the person. Usually, I'm interviewing first and then photographing afterward because then there's so much shared experience to use from the conversation in order to take the portrait. When you have that kind of deeper connection, you get a better picture.

I also knew right away that, given the cognitive decline of my subjects, I would have to work quickly. I would have minimal resources; the lighting and gear and all that stuff could be problematic. I could never bring an assistant.

I started by photographing people I knew from where my grandmother had been and where my wife's grandmother had been. These were people who trusted me to let me in. Once I had some work to show, the circle of trust grew. I made more connections.

DS How long do you typically talk to a person before you start taking pictures?

JW Average, forty to ninety minutes. Some people really want to talk. Some people don't want to talk.

Sometimes I'm interviewing the subject, just the subject. Sometimes I'm with the subject and a spouse or the subject and a caregiver or a subject and an offspring. Sometimes I photograph the subject who's nonverbal, and then I have a separate interview with someone else at a different time. It's a wide range.

DS I'm leafing through your work here, and in almost all the cases, you also include photos of their younger selves.

JW Yes. The only circumstance in which that doesn't happen is when I've photographed somebody who is a recent immigrant and had to leave all their belongings behind. Otherwise, I ask for a photo between ages eighteen and twenty-five. Sometimes I get a younger picture. It's a visual device to get people to consider the whole person and their whole life of experience. It's a visual way to get people to see everything, not just the moment in time that is their journey with dementia.

The other visual device in the exhibit is how they are printed very large as a way to counteract feeling invisible or unseen. Often, they're printed more than a one-to-one ratio, meaning they're bigger than you, and when you're in a room with twenty-eight of them, it feels like they're there with you and impossible to ignore.

DS So, from that exhibit experience, you also wanted the book to be physically large?

JW I didn't want it to be one of those tiny books where things get lost. I wanted it to feel like these are important and precious.

DS How do you think about who will see the book and in what context?

JW If I could have this book in every neurologist's office, that would be great because then people could see people with dementia that don't look like they're in despair, people who have constructive

things to say, people with hope, people with honest conveyances of their grief and hardship but in a balanced way. So many stories of diagnosis feel like a life is over, and the ability to make a meaningful contribution is over, and that's just not true for so many people. If a collection of stories reach people who are at that stage, and it can give them hope, I think that would be so helpful. That's what helped me in the nursing home with Bebe—hearing hopeful stories from others.

DS When you do the exhibitions, do you also have the picture that they gave you of their younger self?

JW Yes. The main image is framed really huge, and then usually to the right of that is what I call the "story card," printed with their name, the old photograph, and the text of their story. The idea is that people are confronted with the whole person. It doesn't feel like an art gallery thing. People engage. You don't go to a show on dementia unless you have some connection to the experience, so when people come to this, they really dig into the stories.

From what I've observed, people are first a little taken aback. Then they're like, "OK, here I am. Am I ready? Deep breath. Let's start reading." Then they engage. Some start to cry. Others grab whoever they're with and say, "Oh, you have to read this one."

DS If someone walks through the exhibition, and they don't read the stuff but are just looking at the pictures, does that bum you out?

JW Totally. I spend so much more time on the stories than the photos. I would prefer someone to consume the whole thing. But I understand that not everyone can. Occasionally, people want to consume it just like a picture book. The portraits are good, but to me, the story is so complex and involves so many people not in the photo. I'm worried that if people don't read at least a little of the text, they're not going to get the more nuanced picture.

I think people tend to project onto a piece of art what's in their hearts and see what they want to see. I'm trying to lead the witness to get to some of the bigger points about my project: that no one is immune, and everyone manifests differently, and that it's important to share these stories and these moments of grace and connection that happen between people during their decline. I don't know if you can access that through a photograph alone. I'm trying to get people to see a more macroview.

One of my bigger fears from the very beginning was that the finished product would be like a yearbook or a catalog—which would be an absolute failure. That would be the opposite of what I'm trying to accomplish. To counter that, I'm working on the photographs themselves and making sure they're different from one another, and that when you consume the work either in person or in a book that you find somebody that you identify with. That connection is so vital because then if you see something you relate to, then you might consider dementia and the public discourse about it and how we all support one another differently because if you're not thinking about anybody but yourself, you're not accomplishing the bigger goal.

DS What is the most important thing that could happen from this book? What's the best outcome?

JW Conversation. That's what I say over and over again. If I can help people have an easier time talking about difficult subjects, then the snowball will roll from there. There are so many positive outcomes that can come from that one simple act.

DS And what is the most desirable type of conversation in your mind? Is it between family members about their loved ones? Is it between the family member and the person with the disease? Is it between strangers?

JW I don't know if I want to quantify.

DS I'll ask the question in a different way. Is there a conversation that you're aware of that's happened because of this project that has just delighted you and made you feel extra proud?

JW One thing I love is when people in my project have shown up to the exhibit. That's happened a few times. It's always really rewarding because the person is easily identifiable when they walk in the room because they've got a three-foot-tall picture of themselves right there. To see how people react to that person when they're there, and, obviously there's a lot of hugging and conversation from me, but then other people are engaging that person with their own stories. "We appreciate your courage"—and then they pour out their own story. There it is. It's happening. People are taking their armor down.

One time the show was at a community arts center, and we had an opening, and I gave my little blah-blah-blah speech, and at the community arts center there was a resident artist who had developed Alzheimer's a few months earlier. So, as you walked into the gallery, there was an external gallery where her artwork was featured. And she was there. That was amazing, because I know she's feeling, "My life is over. No one sees me anymore. They don't look at my art." And then suddenly they are engaging her as an artist with dementia. That was so cool.

One of the women I photographed, Juanita Peterson—she was a PhD and a psychologist at Bellevue in New York, and she's living with her daughter in Roxbury. She came to two of the shows, one at the Umbrella and one at city hall in Boston, and her daughter Lisa came with her. Part of the story is that Juanita feels totally humiliated living with her daughter now. She used to be a PhD clinician, and now she can barely function, and how

humiliating it is for her to have to live in her daughter's home. But yet here they are, words on the wall, and they're out in public in front of the work sharing the story. They're not hiding somewhere else. They're saying, "This is me. This is where I am. I'm here." That was the work actually succeeding.

DS And now you want to get this project into a book form. What do you imagine the conversations are going to be like from a book? It's obviously not going to be the same experience.

JW We can reach more people, be more helpful. We can say to people facing this, "Here are sixty experiences of other people who have dementia and have something important to say."

DS You're extending the reach. You can't take your exhibit into every neurologist's office, but you're pushing it out there with this book.

JW Yes.

DS And are you finished photographing? Or would you like to continue?

JW I'm still working on how to make the photographs more powerful. I think one of the things that I can do, which was something I didn't really realize about myself before, is I can consume grief, which is a skill. If I could figure out a way for pictures to convey that—to visually represent that moment where someone is sharing that with you, it would be useful. I want to capture more of what one observer of my work called "moments of grace." It's when someone is further along in their dementia journey, and they're not cogent very often, or they're not communicative, but they have those moments where suddenly they're fully present, communicating, emoting, connecting, sharing, and maybe it lasts three seconds, maybe it's a minute, and you're in the room. I've witnessed that a bunch, and it's incredibly special every time. I'm working on a way to share that more.

People want to share and connect. There are so many people going through this alone. It's such a cruel irony that people feel alone suffering through something six million people have.

DS Amen. Your work is making a dent in that loneliness.

JW That means a lot. And I'd like to add that, as others have said, if you've met one person with dementia, you've met one person. That's it. Everybody is different. Everybody manifests differently. People handle it differently. I think the human condition is magnificent, and it's the best journey or story you're ever going to get, and this is part of it, and that's okay. Hardship can be beautiful. It's too easy to forget that.

DS Beautifully said.

JW I just want to say, again, I really appreciate your time and that you're willing to engage with me on this. From one artist to another.

DS Thank you for inviting me.

DAVID SHENK is the national-bestselling author of six books, including *The Genius in All of Us* ("deeply interesting and important" —*New York Times*), *Data Smog* ("indispensable" —*New York Times*), *The Immortal Game* ("superb" —*Wall Street Journal*), and *The Forgetting* ("remarkable" —*Los Angeles Times*). He is co-host of the public radio podcast "The Forgetting," creator of the Living with Alzheimer's Film Project, and has contributed to the *New Yorker*, *National Geographic*, the *New York Times*, the *Wall Street Journal*, *Nature Biotechnology*, *Harper's*, the *Atlantic*, *Slate*, and NPR.

PORTRAITS

CHARLIE HESS

younger-onset Alzheimer's disease. Charlie's wife, Heidi Levitt, is directing a documentary film, *Walk with Me*, about Charlie's journey with Alzheimer's. We were connected by a friend who knew the three of us shared the goal to destigmatize those living with the disease.

I asked Charlie when and how he was diagnosed and he told me, "For the last 30 years I've been making magazines—and I could make them so easily. As a graphic design person, everything is very exact and you have to put all of the pieces together exactly right. I describe putting the magazine together as a giant jigsaw puzzle. It was so easy for me to pick the fonts and the illustrations and the photography and put it all together.

"About two years ago, I started to fuck up. I started making some serious mistakes. I didn't know what was happening. There were no words for it. I made a mistake on a cover! And that's when I realized that something was really, really wrong. I didn't know what happened. How did I become so stupid so quickly? I can't even do these things that I could do in my sleep."

After a pause, Charlie continued, "It took a long time, but we started going to doctors. And for a while no one could figure out exactly what it was. Then you start to hear these words that are hard to talk about.

"Once I understood what's happening to me, it was actually easier. Having a name for this thing was better for me. Not knowing what the hell was going on was the absolute worst."

I asked Charlie if any of his friends and trusted colleagues at work had given him any feedback or inquired about his health or struggles, and he told me, "I think I was hiding it. I was realizing it, but I was fighting it. I didn't know what was going on and I didn't want people to know. It made me angry and afraid.

"When you say something like 'Alzheimer's,' 99.9 percent of the people think, well, 'They're dead.' Everybody thinks it's the end in some way or another. But I'm still the same person.

"The thing I want to say is, before I forget it, is that I decided that there is nothing wrong with me. There is no shame in this. And I want to, with whatever time I have left on the planet, I should be proud of what I'm doing, what I've done, my family. And I'm NOT going to go down that rabbit hole. I have nothing to be sorry for."

I asked Charlie if there is anything he struggles with that he would like to share and he said, "Yeah. It's fucking hard. It's as simple as that. Some days I can get through the day pretty well, but every day is harder, and I forget things. This happens all the time and I have to spend an hour looking around the house for the thing I lost. I can't speak as quickly as I used to, and my friends and family still talk quickly. Sometimes I can't even get the words out in time, so I'm sort of left behind a bit, and that's a thing that I'm dealing with.

"This week was hard. I was losing things. I couldn't remember why. I couldn't remember what I was supposed to be doing. I'm forgetting things, and this week was particularly bad. I knew that this would happen, but I hope we have many better days as well. There's not really much you can do

with it when you're in this situation. Everybody tries to help, but you're your own burden. Everybody can try to help, but they can't really understand. You can't know what it's like if you're not in it.

"Some days are better than others. On the shitty days, you really know it, and I don't know what to do on those days. I'm working on that. In this last year, if I'm being totally frank, I think it's getting a bit worse; not so much that I can't go out in the streets or anything, but I can see in myself that things are just harder."

I asked Charlie, "How do you want to push back on that stigma with the movie, the documentary?"

He said, "I guess my answer is, I don't have a choice. I can't speak for other people and how they respond, but for me, this is what I've been given, and I'm going to do absolutely everything I can do as long as I can do it.

"I'm doing this possibly for other people, but definitely for me. I can't imagine what I would do without it. It just gives me, I don't know, purpose? I don't think I could get up in the morning without it. It's kind of saved my life, as funny and stupid as that is.

"I found a way to be useful. We are creating this film, this documentary, and I want to live long enough so that people will see it finished and all that we've done as a family to do something positive." ∎

DAISY DUARTE

spring day in Missouri on the Washington University Medical School campus. We were introduced by a friend a few weeks earlier and had spoken via Zoom before I was fully vaccinated against COVID-19 and able to travel safely. Her infectious enthusiasm was obvious during our conversation and positively electric when we met in person. She greeted me with a warm embrace and smile, reiterating her commitment to telling her and her family's story—resolved to make a difference in any way she can.

Daisy is a passionate advocate for people living with Alzheimer's disease and a committed clinical trials participant.

After a lengthy process, that included a few painful and confusing misdiagnoses, her mother, Sonia was diagnosed with Alzheimer's in 2013. As part of that process, Daisy and Sonia's doctor interviewed Sonia's extended family in Chicago and Puerto Rico and discovered most of her mother's family has a connection with Alzheimer's.

Daisy told me, "Seventy-five percent of my family has been affected with Alzheimer's. My grandmother was part of a family of 11 siblings and all of them have passed away with Alzheimer's. My mom, Sonia Cardona, is from a family of six siblings, and four of them have passed away with Alzheimer's.

"Now we come over to my generation. I have a brother and a sister and myself. I got tested, and I do have the mutation, and I'm guaranteed to have it by the age of 65.

"The doctor asked me if I wanted to be in a clinical trial, to think about it. I said, 'I have nothing to think about. I want to be in it. I'm not going to be another number in my family. I'm going to fight for it. If I'm going to die, I'm going to die fighting.' I'm 45 now."

After Sonia's diagnosis, Daisy took on the responsibility of being her mom's caregiver. She

closed the sports bar she owned in Springfield, Missouri, and dedicated herself to caring for her mother. Daisy simultaneously enrolled in the Dominantly Inherited Alzheimer's Network (DIAN) research study led by Washington University's School of Medicine in St. Louis.

Daisy told me, "I'm 45 and have been in the trial for six years. I enrolled in the clinical trial, and the rest is history. I'm still here . . . I travel all over advocating. It's a passion for me, because I refuse to go down, just letting Alzheimer's take over me. It might take me down. I'm not going to lie. It might. Do I fear it? No! Because I know I'm fighting it."

Sonia recently passed away, and I asked Daisy, what was the hardest part of their journey together.

"Out of the ten years, the toughest was the beginning stages, because you see a strong, independent woman, that raised three kids on her own—she did the best that she could with us, and she did an amazing job—just deteriorate before my eyes. For me, the role changed. I was the mother, and she was the daughter. That's the toughest part. She was very strong, very independent. She fought for what she believed in.

"She was just all around amazing. The one thing that I loved the most was her smile. I want to carry on, how loving, how caring she was. If she believed in something, she went for it all the way, and that's the same model I live right now. I believe that we can find a cure for Alzheimer's, and if this trial doesn't work and I have to be in another four, five trials—until my last bit of memory—then that's what I have to do."

I asked Daisy, "After taking care of your mother for ten years, what advice can you share about compassionately caring for a loved one with Alzheimer's?"

"It doesn't matter how far gone they are into the disease. They still have ears, and they still have a beating heart. You always, always want to show them compassion, love, and respect. So, whatever you say negative in that room, they're still taking it with them. They're still taking it in, so just treat them the way you want to be treated. Just treat them with respect and love. That's one thing I always did for my mom." ▪

JAY REINSTEIN

our mutual friend Arthena Caston who is a vocal advocate for people living with younger-onset Alzheimer's. She suggested that Jay shared our commitment to eliminate the stigma of living with dementia and that we should meet and talk.

A few months later, I traveled to Raleigh, North Carolina, to meet Jay, and we hit it off right away. Jay is a charmer. His energy and charisma are obvious within moments of meeting him. Everywhere we went, people recognized Jay and wanted to talk with him.

Jay told me, "I am 60 years old, and I was diagnosed with early-stage Alzheimer's when I was 57. I don't have a family history of it.

"I had been a 30-year public servant. I worked for city government. The last six years of my career, I was the assistant city manager for Fayetteville. I loved doing what I was doing. The journey definitely started for me before my diagnosis. I started noticing I was making more lists, working longer hours. It was just taking me longer to do my job, but I attributed it to information overload—that there was just so much on my plate.

"If you know anything about city management, we had about 210,000 people. There was always something going on. I think one of the first indicators to me, when I really started to think something was up, I remember meeting with a community group, and someone asked me the departments that I supervised. I couldn't remember any of the departments. One of my staff was there and rattled them off.

"I knew someone over at Duke and he got me set up with a neuropsych. Six months later, they did another neuropsych, and there were some changes in my cognitive ability. They did a scan, maybe MRI, PET, I think something with amyloid plaque, and the diagnosis was early-stage Alzheimer's.

"I didn't know much about the disease, so when we got the actual diagnosis, I don't think it hit me right away. It took a few days for me to realize what

the diagnosis would mean to me and my family. I became a bit withdrawn, depressed. I just remember I was more concerned about the void it was going to leave, because I was going to have to retire. I didn't know where money was coming from, and I was such a workaholic, what the hell was I going to do all day?

"Oftentimes when you make an announcement, it's never good on the job—you're sort of pushed out, or something negative happens. Well, I was embraced by the city manager and the elected officials. I had a three-month transition out of the organization, because I wanted to go public. I'm a very outgoing individual, and I thought that this was really an opportunity to raise awareness and educate folks. To really let folks know that it's not a death sentence, that we can be productive. Live life. And that's what I'm doing.

"I'm still very active. There are things that I just can't do as well anymore, and I know that, but I really focus on the things that I can do well. I'm on antidepressants. I take Aricept and Namenda. I think it's helped me a little bit with my focus, I believe, maybe a little bit. My doctor said I can still drive. I use GPS. I'm not really supposed to drive long distances. I'm just trying to live as close to a normal life as possible, and it's not always easy."

I asked Jay what's the most rewarding part of his advocacy work and he replied, "While I like speaking to groups, at the end of the day I want to find a cure. But I also think it's educating folks. I've been in situations, and we all have heard the stories, immediately when they hear 'Alzheimer's,' it's like your life is over. I think, when we're living, we have to try to reduce the stigma. It's such a big part.

"I just saw a couple of my lifelong friends—50 years one and 40 years the other—I don't see them all the time, but we see each other enough, and the first thing, both of them said, 'You look great. You don't look like you have Alzheimer's.'

"I think we must let people know that with this disease we all progress differently. We might look different. There will be a day that I'm sure it's not going to be good, but until I get to that point, I could be at this stage for three or four more years.

"I don't know. The sad part about the disease, and I think where I get really sad and when I reflect, I have a couple of friends in my support group and they're both younger than me, I think 55, 56, and they're both in adult daycare. When they're in support group, they're not part of the conversation. It's sad, and that's happened in two years. They have progressed so quickly, so that's my fear."

I asked Jay to tell me more about his fears and he shared, "For me, it's having people see my decline, having me be a burden to my wife and daughter. My wife, we're both 60, so we're not super young, but we have some good years ahead, and I think the fear of what that life is going to be like for her and I. She worries all the time. She's really depressed, and I think, having a more difficult time. I think for my daughter, I think that while she's very supportive, she worries a lot about her dad. It's what is life going to be like in two years, three years, four years, five years? Am I going to remember them? Am I going to be able to be at my daughter's wedding? Am I going to see more grandkids? Those are the things. I just went to see my grandkids in Georgia a week ago. Oh, my God. I want to go back tomorrow. I want to spend as much time with my grandbabies as I can. That's what I worry about, because I love people. I am a people person, and I think the loss of connections, my friends, I've got a lot of friends. I love seeing people. That scares me. It scares me a lot." ■

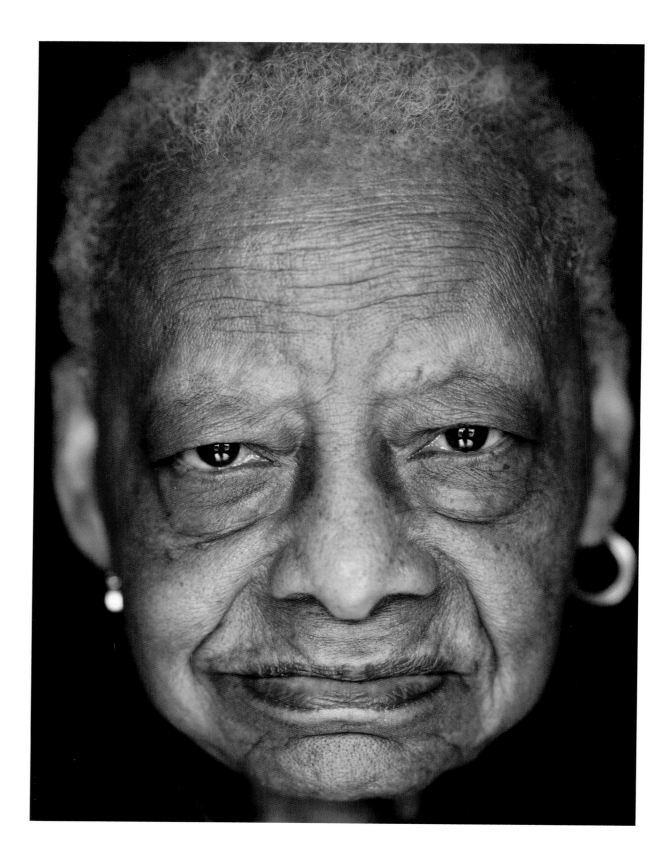

EDWINA FRANK

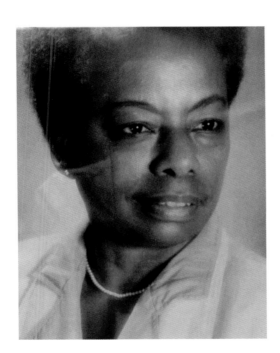

Dr. Edwina Frank at a senior living center on a beautiful spring morning in Atlanta, Georgia. Stephanie and I first spoke by phone, and it was immediately clear we share a desire to destigmatize folks living with dementia by focusing on their humanity and individual stories. We agreed I would visit them in Georgia to meet Edwina and talk again in person.

Two months later, Edwina greeted me eagerly from her wheelchair and waved me over to sit with her. Her speech was difficult to follow but her energy and animation seemed boundless. If anything, Edwina seemed frustrated that her daughter had to help fill in the blanks or complete her sentences. Stephanie brought out some old photographs and newspaper clippings and began to tell me about her mother.

Born and raised in New Orleans, Edwina is highly intelligent, motivated, and stubborn (according to family at least). Edwina was a standout student, advocate, and teacher. She has a PhD in both education and psychology.

Edwina graduated from Dillard University in 1957 and founded several nursing programs in the state of Louisiana, including the nursing programs at Loyola University in New Orleans and Southern University in Baton Rouge. Prior to that, Dr. Frank was the director of nursing at LSU Medical Center, and Stephanie proudly described the huge portrait of her mother that hangs there today. Dr. Frank has had an outsized impact on Louisiana, the city of New Orleans, and tens of thousands of nursing students over the course of her lifetime.

Stephanie told me, "In 2012, the pastor at her church called me and said, 'Stephanie, your mom is getting lost in the church.' I'm thinking, it's no big deal. The pastor was like, 'Are you sure?' I said, 'Believe me, she gets lost all the time.' The pastor replied, 'Well, it just seems different but okay we'll just keep an eye on her.'

"Finally, I went home one weekend, and she just looked completely different. She looked a little dehydrated. Her clothes weren't as clean as they had been in the past.

"Some of my mom's friends in her church had been calling me, telling me that she's been acting different. I just wanted to come to her doctor's appointment to see if there was anything that we needed to do, or I needed to learn or understand about what was going on with her health.

"The doctor said, 'Oh, great, I would love to have you,' but my mom didn't know. She thought I was just driving her there and didn't know that I was going to go in the room. She got really agitated. She told her doctor, 'I don't want my daughter in here. I don't want her to know my business.' The doctor said, 'I think it's a good idea for you to have her here. I would like her to stay here.' I was like, 'Ma, I'm not leaving.' I was adamant about it.

"She was 84, but when I say this lady was still walking around, going to symphony rehearsals, performing in the symphony on a regular basis, she was still very active. She was still driving. She was going to everything that was familiar to her. But while I was there, her doctor told me, 'Your mom's been struggling with memory loss for about six years now.' My mom got really upset with the

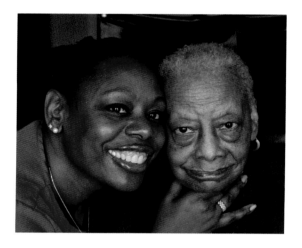

doctor and said, 'I don't trust her. I don't want her to know my business,' talking about me. 'This is not anybody's business.'

"She had been hiding it from me. From everyone.

"Now she's with me in Georgia. She's in a very safe space. She's not living with me. She has advanced Alzheimer's and dementia, but it's so crazy, because if you look at my mom today, she's still super funny. She's still super smart. She doesn't speak as well as she used to. She doesn't have a huge vocabulary anymore like she did before. But she still knows French, so when she gets angry, she speaks French or Latin to somebody, and she's using cuss words. She knows my name very well, and if she wants something done, she knows that all she has to do is call Stephanie and she'll get it done. When I say she is still very feisty, she is 92."

I asked Stephanie what advice she would give someone else who may be starting this journey with a parent or loved one, and she said, "The

minute that you see your mom starting to become aggressive, it's time for you to take control of the situation. When it comes to your loved ones, you have to have patience and empathy, and you have to rely on your faith a lot more than you've ever done. For me, because my mom is my world and my heart, that patience and empathy came automatic.

"You have to stop thinking about yourself, and you have to think about them. You can't be selfish. Everything that you probably said that you would do in the past, now you really need to figure out what's best for them and how you can best help them to live the rest of their life out, just with a great quality of life. I can honestly say if my mom were to pass away today, my heart would be completely broken, because she's still my world, but I know for sure that I've done everything she could have wanted a daughter to do."

"Tell me about how you share time with Edwina and how that has evolved as her dementia progressed," I asked Stephanie.

Taking a deep breath, she responded, "I get off at work, leave Delta, drive 33 minutes, go to the senior-citizens' home, give her shower, make sure she eats a decent meal, sit there and talk to her while she's eating, read the Bible, read a book, and then just stroke her and let her know I'm here. For me, people don't realize that just because your loved one might have changed and made a

transition mentally, they never forget how much you love them. Even during the pandemic, if I just went and stood by the window and sat in a chair for two hours just sitting by the window talking to her, she remembers that. She'll turn and be like, 'Stephanie, are you there?' and I'll be like, 'Yes, I'm here.' When she sees me, even when she's in the worst of moments, something will click and she'll be like, 'Well, just get my daughter.'

"Just spend time doing some of the things that they used to like. She loves books about New Orleans, so I bought her these beautiful books to read about Mardi Gras. To talk about her ancestors—I have pictures of my great, great grandfather. She was working on the genealogy of our family, so I will talk about my great, great, great grandfather, five generations back.

"It's really about you learning who they are today, and, just like you said, capturing those moments, savoring those moments. There's no way I can just go in her facility for 30 minutes. I wind up spending three to four to five hours, or until she goes to sleep. Then I can kiss her and say, 'I love you. I'll see you tomorrow.' To me, like you said, it's about the compassion. It's about showing them love. This is a disease that they did not ask to have. It happens. You can't just forget about them." ∎

GENTLE
VANDEBURGH

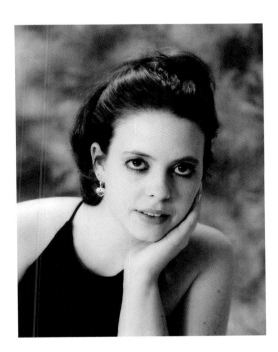

takes an incalculable toll both on the person with the disease and their family. Each chapter presents new difficulties but also new opportunities for love and understanding. Alzheimer's can overflow your cup with hard lessons that come after failure and perseverance.

Gentle VanDeburgh's family has a history with dominantly inherited Alzheimer's disease, and she has the genetic mutation herself. Gentle knows she will ultimately have the disease like her father, Steve. Gentle spoke to me from her home in Oklahoma. We spoke of her family and growing up in Texas. Our children are similar ages, and she joked that we might be interrupted at any moment by an animal or a child. We spent a couple of hours talking, laughing and crying together. Gentle courageously shared her journey with me. Together, we share the determined optimism that something positive can be born from so much hardship.

She told me, "It's through my dad's maternal side. He's the oldest of four, and we know three of four have the gene. My aunt died earlier from cancer, so we don't know what her status was. His mother Jane was the oldest of three kids and two of three died with Alzheimer's. The generation before that I think there were 13 children—and it's either 9 of 11 or 11 of 13 had it. A devastating number.

"He was 52, and we were like, okay, something's wrong. We know what this is. He was one of the first family members who went and had the genetic testing done before his symptoms got really bad. That was 2011. My mom died suddenly in 2009, and I think had she been alive, he probably would have just been like, let's wait and see. But I think he wanted to be more prepared, because we would be the ones taking care of him. Mom wasn't there. I think that's why he went ahead and did it.

"He got almost a decade of being independent, more than his mom did, and his brothers. I think

that was awesome, so he got to be with my sister and her family in Amarillo. He got to be with those grandkids and be close to them, which is wonderful. It's good.

"He died six weeks ago in January from COVID.

"It was so strange to me to see how COVID was so different for him. He had no respiratory issue—he was fine—but it totally devastated his cognitive function within days.

"He had just moved into the nursing home side, and a week or two later tested positive for COVID, and so they had to move him into the COVID unit, which is part of the nursing home. When he moved in there, he was still walking around and being nosy, getting into trouble. He would just sit down with the nurses and be like, 'Hey, what are you doing?' 'Well, my job.' Kind of getting in trouble. He was dressing himself, toileting himself, and then in a matter of days he was nonverbal.

"He kept trying to walk, but he couldn't, and so he kept hurting himself. It was this whole thing. It was just so fast.

"When he first tested positive, they called us, of course, and they were like, 'He's tested positive, but he's really doing well. He's asymptomatic. We'll let you know if anything changes.' Obviously, we could call and talk to the nurses, but we couldn't go visit him. In the space of a weekend, it went from that to 'Get here! He's not going to last much longer. If we move him to hospice care, you can come see him.' That's what we did, and we basically just dropped everything.

"My brother and I live three or four hours away from where he was in Amarillo, and we just dropped everything. I picked him up and we went. By the next day we got to him, and he was almost unrecognizable, curled up on the floor. His knuckles were bleeding. He was all battered up. They had started the morphine and stuff, because we had said we know that he does not want to be on life support. He's been very clear about that forever. We know what he wants. We need to let him go.

"He had to start off on such a low dose of morphine, he was very agitated as they were moving towards that, and so my brother and I ended up that afternoon physically holding our dad down, because he was trying to get up, and he would fall. It was a nightmare. We saw him Tuesday, and then Thursday he passed away. We were with him that whole time. It was so weird. My brother and sister and I, we didn't ever really say it out loud, but the second we saw him, we were like, well, there's going to be one of us here

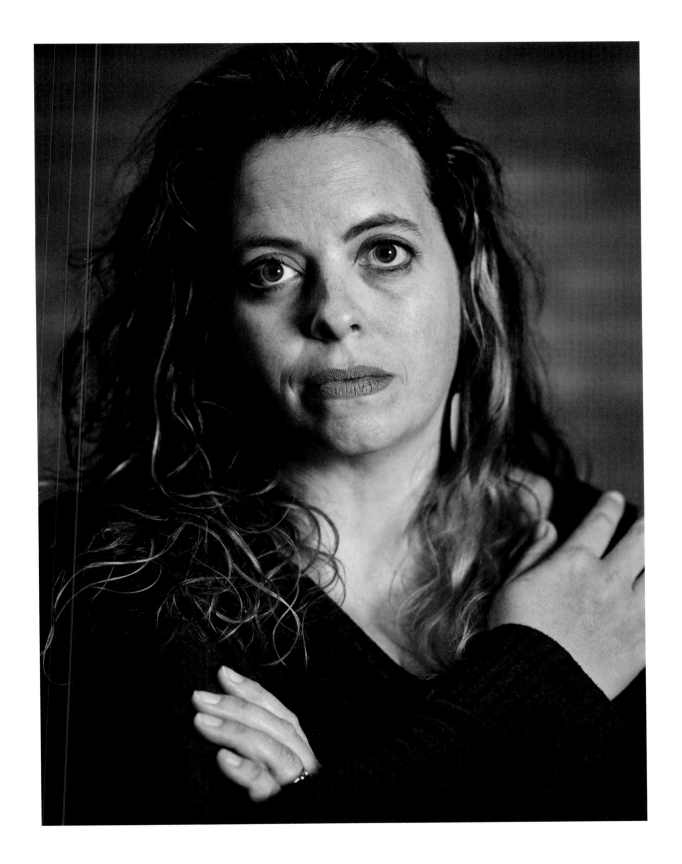

until the end. We're not leaving him alone, because it was obvious that he needed somebody with him. I think he knew that we were there. He recognized my brother and talked a little bit. He just said, 'I love you,' to Josh, so I think he at least knew that we were there with him, but it was super, super shitty."

After a long pause, Gentle told me she had been tested alongside her dad back in 2011. She spent ten years watching her dad's journey—and ultimately his death—knowing she would eventually travel the same path.

I asked Gentle how her husband Drew handles this, and she told me, "He's very easy-going. I think he also expected it. He knew about this before we got married, because I was like, 'I need you to know there's some significant strings attached here.'

"We were both of the same mind once Hazel [her oldest child] came along, that we would just make the most of what time we have, hoping that there will be advances, and if not a cure, then at least some good treatment by the time we need it. In the meantime, just be here with them and give them that start in life. We decided early on that I would stay home with the kids, for the most part, and just enjoy them and be the mom.

"I was lucky as a child to have an amazing mother who was always there for us and was there with us and all these great memories growing up in the country, just being a kid. I want that for them. One of the reasons I wanted to find out was

so that I would know the timeline, in a way, and that I wouldn't waste any time.

"I just want to make sure and give them that, because I may not be here later. I think that's how it's affected both of us. Drew's always been super, super supportive of being part of this study and making sure that happens, because I feel like that's how we can be useful and contribute."

I asked Gentle to tell me more about the desire to cram, to make the most of every single moment.

She replied, "I want to fill them up with memories and stories so that they have that going forward. In case I'm out of the picture, for whatever reason. Having that very real possibility of there not being a later, I feel like a lot of people are like, well, we're going to work really hard, and we're going to make a bunch of money, and then when we retire, we can enjoy our grandkids. There's a good chance that I won't be here for that, or at least not in any way that I can plan on.

"We're a little bit different in that way. We're not so much focused on later. It's more like, okay, what's the best thing we can do for the kids right

now? I've been really focused on not wasting time being unhappy, not wasting time being in a job that takes me away from my kids or that I don't feel like is worth it. It's been great.

"I'm really, really passionate about kids being kids and getting to be, well, just kind of feral. I don't like the structure of it all. I remember growing up. We had a dairy farm, so I grew up in the middle of nowhere, and we would just go play. Mom would be like, 'Leave the house. Go, and when I honk the horn on the car come back.' We had a big pasture that was ours, and my brother and sister and I and the dog, we would go off and spend all day just wandering around playing whatever games we thought of or adventuring, collecting cow bones, whatever. I don't know how we never got bit by a rattlesnake, but it didn't happen. I really don't know how we avoided that, but I guess that's what the dog was for.

I asked Gentle why she participates in the DIAN study. She explained, "It's the only thing I can do that I feel makes any kind of impact for my future and for the kids. For my kids and everybody else's. I'm not a scientist. I'm not a doctor. I don't have that skillset. I'm not a legislator, all those things. This is what I can do. I can let them look in my head, and I can take these tests and go through this, which is not easy, but that's what I could do. I feel like DIAN at least has done a really good job of at least making me feel like that's helpful. I'm

doing something, because the very worst thing was watching Dad get sick and watching Grandma get sick and being helpless, not having any kind of recourse at all and just having to sit and watch that happen and wait for it to happen to you. That's what the situation was a few years ago. Well, you just must wait and see if your turn comes, and you don't know, but now we do know.

"I just feel like DIAN has made such a difference to so many families, because this research directly impacts everything, almost all the advances that have been made in the last decade as far as understanding this disease; maybe not treating it yet, but understanding it is from the data they're getting from us, and without us we would still be just sitting and waiting. I don't think anybody wants to do that."

I asked Gentle what message she would like to give her kids if they can't read or hear it for ten years—like opening a time capsule. She responded immediately,

"Don't be scared!"

"I'd tell them the same thing I tell them all the time. They're everything. I don't know who I was before them. I am definitely happy to be their mom. I hope I teach them enough so that they can do whatever they dream—that they'll have the courage to do that. And to always be themselves." ∎

JUANITA
PETERSON

shake and warm greeting. She listened patiently as I explained this project and gave a little background about myself and my family's history with dementia. She agreed to let me take her portrait and tell her story because she adamantly wanted to help others with dementia if she could. But she asked me to come back another day because she didn't like her appearance today. I gently explained that we had a similar conversation two weeks earlier and that today was the day she had chosen for me to come back. Juanita quietly sighed, nodded her head, and said, "Okay. I'm ready then."

Juanita described that she was born in 1939, one of seven children, and grew up in Winston Salem, North Carolina. After graduating from high school, she moved in with an older sister in New York City to attend City College. During that time, she met her future husband, Alonso (Al), who was from Tuskegee, Alabama, and a New York City police officer. She continued her studies at New York University, earning a PhD in clinical psychology. For twenty-eight years, she worked with adolescents and adults at Bellevue Hospital. After retiring, Juanita and Al moved to Chesapeake, Virginia.

When I asked Juanita how she came to Boston, she replied, "I'm still trying to recapture information, but it just blocks out. I don't have details on what happened to me. All I know is that one day I woke up in my daughter's house. And that was weird. I've been trying to recapture what happened—it's a total blackout. I don't remember being ill. I just remember waking up in my daughter's house. I don't even remember being in the hospital."

I asked Juanita about her dementia and how it feels to not remember, and she replied, "It feels awful. Let me tell you. It feels like a part of my life is cut off and I can't get it back. I really feel sad. The other day I couldn't remember my husband's

birthday. How could I forget that!? It's frightening that you could not remember things that were so important to you."

Later, Juanita's daughter Lisa explained that Al was diagnosed with Lewy Body dementia in 2015 and passed away in 2017. Juanita was diagnosed with dementia in 2016 and her memory decline accelerated after Al's death. In 2018, Juanita was hospitalized with a bowel obstruction, and Lisa decided it was no longer safe for Juanita to live in Virginia and moved her mother into her home in Boston. Lisa told me, "She misses Al. He was her rock. I think she finds living with me demoralizing and humiliating. She was so independent and used to making her own decisions. It's definitely shifted the family dynamics. Everyone has learned to be patient and more understanding."

It was then that I remembered asking Juanita, "With all your work and life experience, what advice would you give someone?"

Without hesitation, she told me, "Just be yourself. Be honest. Whatever you feel or think, you should be able to express that and treat people the way you want to be treated." ∎

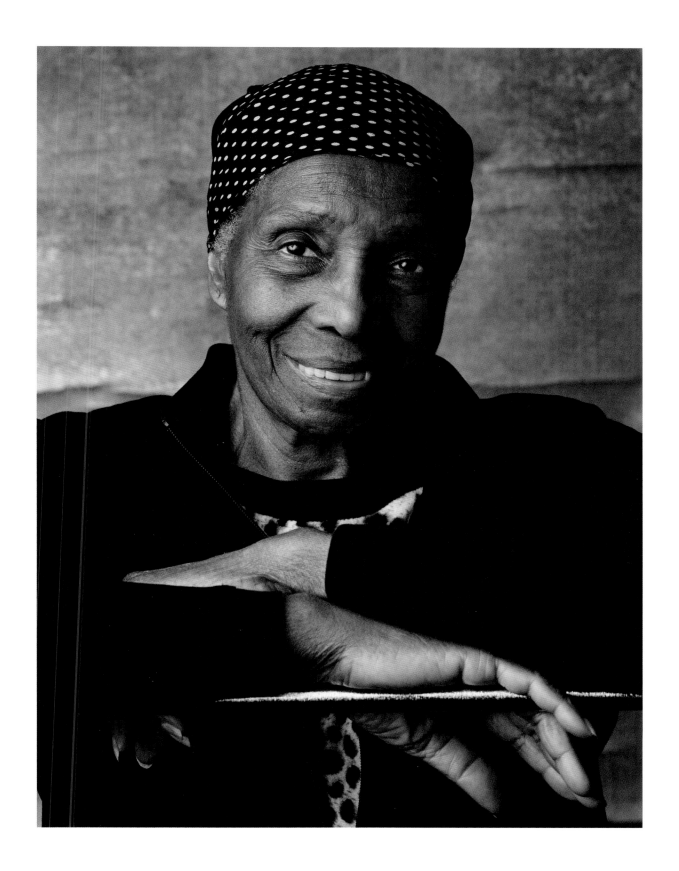

PHYLLIS NEWELL
KIRKPATRICK

PHYLLIS NEWELL KIRKPATRICK AND I WERE introduced at her daughter's home where she's been living for the past few years. Energetic and eager for conversation, Phyllis regaled me with stories of her life and work.

Born in 1934 in Queens, New York, she studied piano at the Mannes Music School in Manhattan and stumbled into modeling after she began babysitting the infant of a model who soon connected Phyllis with her agent.

My favorite story was about how she met her husband. "We met under a tablecloth at a party. He was not my date. He saw me crawl under there and a few minutes later he joined me. And that's how it all started!" This anecdote captures so much about Phyllis, flirtatious, funny, independent, and keen to write her own story.

She had four children in New York, and her growing family ultimately moved to Ashfield, Massachusetts, where she started an antiques business.

The last few years have brought enormous struggle and change. After being diagnosed with Alzheimer's, first she had her driver's license taken away—which she compared to having a limb removed. Next, she's had to give up her own home, control of her finances, and move in with her daughter Beth. She maintains a positive disposition most of the time, but the loss of independence and being categorized as "elderly" or "sick" clearly chafes Phyllis.

Phyllis and her daughter Beth are on a humbling path together. Frustrating and sad perhaps, but also beautiful. A reversal of who is the caregiver, offering unconditional patience, comfort, and sanctuary. Together, they are finishing the last chapter of a beautiful adventure. ∎

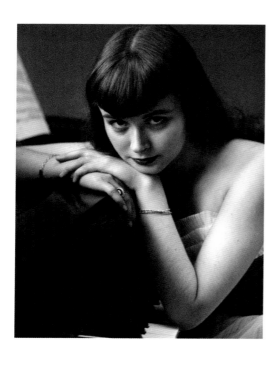

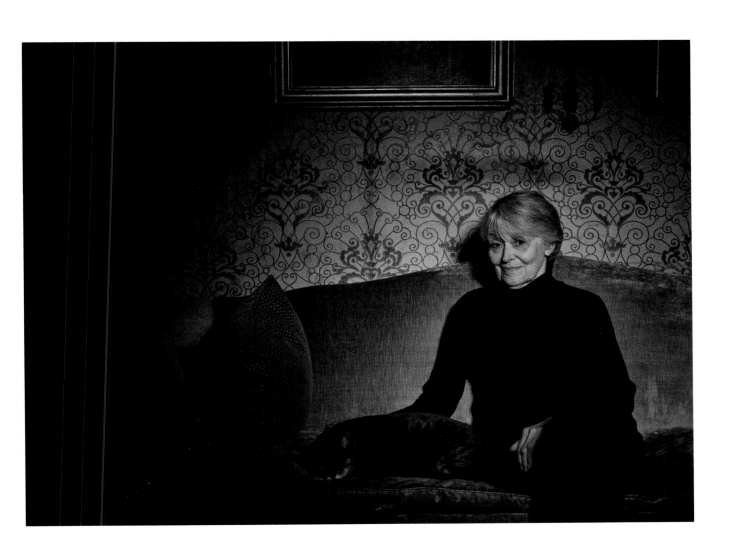

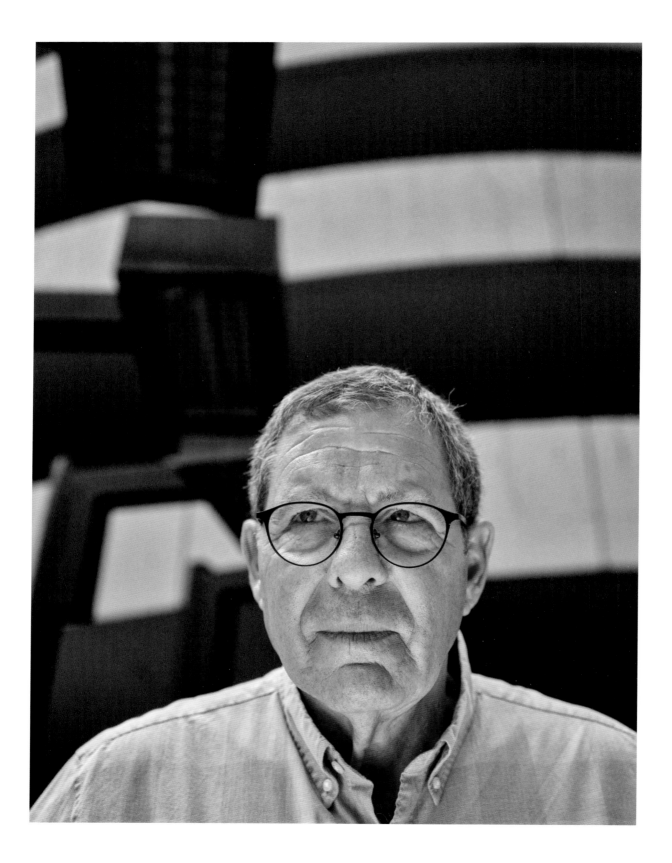

JIM BUTLER

JIM BUTLER WAS DIAGNOSED WITH ALZHEIMER'S five years ago and has been a vocal advocate for those living with dementia for several years. Jim and I spoke on the phone and via Zoom a few times before I traveled to Chicago to meet him and his wife Lisa.

Jim told me, "I grew up on the south side of Chicago. I worked for the city. I was an electrician for a while early on. As an aside, my uncle was Richard J. Daley so our family had a little political clout. Chicago has more lift bridges than any city in the world, and I was in charge of the mechanics of all that for a bunch of years.

"I got married. My first marriage was very early. I was about 19 years old. My girlfriend got pregnant, and we got married. We were together for about 11 years, and then we divorced.

"When I got divorced, I moved up to the Lincoln Park area—Old Town in Chicago. I was single and living the life, which included about three or four years of cocaine use . . . cocaine abuse. I remember the first time I did it, I said, 'Wow, I've never felt so terrific as I have tonight. I'm never going to do this stuff again,' and I didn't do it again for another year. If I ever do this again, I'm going to get hooked on it, so I didn't do it for another year, and then about a year later, I did it again, and I got seriously hooked. I spent the next three years and change acquiring cocaine and going through all the stuff you might imagine when you're dependent on cocaine.

"I went into treatment.

"I went through aftercare after the program, but they invited me to come on in and answer the phone and help people make a decision to come in and get treatment. I started doing that, and it was helpful to them. To make a long story short, that program that was about 20 beds and it turned into two treatment programs in Chicago and two programs in Detroit. I became the managing partner and CEO of the group. That's what I did for the bulk of my career. I was in the addiction treatment business.

"Fast forward to 4th of July weekend five years ago. My iPhone conked out, and I went to the Apple store in Chicago. The tech guys were giving me a new phone and trying to tell me how to do it, and I couldn't do any of that stuff. It brought to the fore something that I'd been quietly sitting on for a good while, and that was my memory. There's something going on with my memory. I get confused. 'What did I walk in this room to get? Where was I going with that train of thought?' Tasks that I had done many, many times, I couldn't remember how to do them, and I was doing that all internally. I didn't share anything with Lisa for months and months, until that 4th of July episode.

"It kind of brought me around, but I had been experiencing cognitive hiccups, as I refer to them, for a good while before that. I was just carrying it inside. I look back on when that happened—when I went up and I told people. That was my time. I said, 'Jim, you've got to quit fucking around with this, and you need to get it checked out.' That was the thought that was going through my mind. And I did just that.

"I went and got a diagnosis at Northwestern Memorial in Chicago. About three or four months later after a lumbar tap and cognitive testing and all this and that kind of stuff, they diagnosed me with Alzheimer's.

"For that first year or year-and-a-half, I shared my diagnosis with no one."

Lisa added, "Right away, after the diagnosis, they let us kind of lick our wounds for a couple of weeks, and then reached out to have us come in and talk to the social worker that started sharing all of the different things that were available to us through the hospital. Jim said, 'I don't want anybody to know,' and I thought, 'Well, I've got to talk to somebody about this,' because I was crying all the time in the shower, so I did. I told a couple of girlfriends."

Jim continued, "I think we were both trying to pretend to be strong. We were trying to pretend to be strong for each other.

"I ended up getting hooked up with the Illinois Alzheimer's Association. We would go to support groups, and the care providers would go in one room, and we with the diagnoses go in another. They'd have one of their staff there to talk about what we're doing and to have some fun, and also look at some stuff. How are you feeling, what are you doing about it, and that kind of stuff.

"There's a woman there, Peggy Rubenstein, she's a dear friend of ours, and she said 'I'd like you to tell your story at a Walk to End Alzheimer's in Glenview' where the old Glenview air station was. Lisa helped me put a ten-minute talk together. There were probably 1,500 people there. I gave my talk, and we were driving back, and I said to Lisa, 'You know, Lisa, why am I not sharing my diagnosis? I just shared it with 1,500 people! Why am I saying this like I've got some horrible disease that's contagious? Why am I hiding it?'

"That was the kicking point for me. For crying out loud. You haven't done anything. You haven't done anything wrong. You're not getting out of jail recently. You've got Alzheimer's.

"Peggy asked me to do another thing, and then they asked me to do another thing, and pretty soon I find myself advocating for Alzheimer's, and it's feeling like it's bringing a lot of purpose into my life. I certainly started sharing."

I said to Jim, "I'm interested in you being an addict, and then being in the business of treating addiction. Now with Alzheimer's, you're helping people face their diagnosis. It's not an addiction of course, but it is an incredible hardship. One that can be humbling and force you to ask for help and face your own vulnerability. Is there a link between having gone through the fire yourself and how you help others now? Is there a relation in the human skillset? There's an empathy. You seem to have an ability to connect with people and to use empathy. Tell me about that."

"When I got in that business, I was very good. I knew what I was talking about, because I had covered

that ground. I could talk about my experience and that would resonate with people. That took me years and years to get to that place when I was working in the drug and alcohol treatment space. After I got my diagnosis of Alzheimer's it took me only a year-and-a-half to do it because people invited me to go to this, invited me to go to that. I was blessed with a lot of wonderful mentors.

"I'm no expert at this thing. I'm just coping. What am I trying to do with Alzheimer's? I look at someone and I want to be pleasant with them, and I want to share a nice moment with them. I'm in a gentler place and I'm responding differently. Things I cared about a whole lot a long time ago I don't give a shit about. I care about people. I care about my family. I care about the great stuff I have in my life. Advocacy is a way to do that for Alzheimer's. Maybe I'm just hanging in tighter. I don't know. I'm grateful for where I'm at. That's the best I can put it. I'm grateful for everything."

I asked Jim, "After giving dozens of talks, what resonates the most for you or your audience?" Jim responded, "The most important thing for me over the past four or five years has been to learn to be gentle with myself. If I got jammed up and frustrated with every cognitive issue, I had in a given course of the day, it would be horrible. Even if I'm at a grocery store, I'll say, 'Could you repeat that again? I forgot.' I don't tell them I've got Alzheimer's. I just say, 'Would you do that one more time for me?' kind of thing.

"I have dozens of times a day where I lose my train of thought, or it's going to slip away, and I try and smile at that and move on. But it's frustrating. It's frustrating. It just is. It'll come back to me later, and I'll interrupt Lisa and say, 'Here's what I was going to say before,' and she says, 'Could you save it for a minute?' and I say, 'Not if you want to hear it again, because it'll probably go away again,' that kind of stuff. We have a little fun with it."

I asked Jim, "What do you and Lisa talk about for your future?"

Jim paused for a minute and said, "We've had some conversations about . . . if it becomes more difficult, that I'll be a real burden. That's a different phase of stuff, but they say in AA, 'one day at a time.' I often think quietly at night that she's the one that's going to have the problem. My dad had Alzheimer's, and I remember his process through that. Lisa's going to have that burden, and it breaks my heart. It breaks my heart. My guess is that moment will come for her. We don't talk about that. But we do talk about getting organized and having the right stuff and making the right decisions."

I said to Jim, "If you could share some of your strength with people that are beginning this journey, what message would you give?"

"I would encourage people that are getting a diagnosis like this to get with other people. Get in support groups with people and learn from them. Mix it up with them. You don't have to talk even. You could just show up and listen. If you feel like talking, by all means talk because you'll get a lot of experienced folks that have been covering this ground for a while. You can get tears in your eyes. Good tears. And wonderful stuff happening, or your heart breaks a little bit because someone's sharing something. There is all kinds of stuff, doing this here and that there, but I'd enjoy being with my peers. Understanding them. Helping them. Laughing with them. Making fun of each other. Going back and forth. That's great stuff." ∎

BAMA BRADLEY

ON A COLD WINTER'S NIGHT, BAMA BRADLEY and I met for the first time, face-to-face but separated by two screens and a thousand miles. We had a raw, tearful conversation that ended with promises to visit in person once spring and vaccines arrived.

Two months later, I was able to travel to meet Bama and her family at their home in Springfield, Missouri.

Bama told me, "I'm third generation early-onset Alzheimer's. My brother passed away a week ago from early-onset. He was 33. My mom passed away at 34. Her mother died at 26.

"I am 29. I was diagnosed in 2017. I'm going to make it to 30."

Bama has dominantly inherited Alzheimer's disease, which is a form of dementia caused by rare, inherited gene mutations. She participates in research led by the Washington University School of Medicine in St. Louis. I asked her why she wants to be involved in clinical research and she replied, "I was 11 when my mom passed, and I remember her. I have a daughter now, and I want to make sure that she knows everything she can so she can beat it. She has a 50/50 chance of having the mutation, so I want to learn as much as I can—not only for myself, but maybe a cure someday. Maybe I can assist in that. That's what I want to do."

I asked Bama about her mother, and she told me, "By the time I was old enough, she couldn't talk super well. She probably talked a little like me—she couldn't get words out. So, I only knew her sick. I didn't realize that she was different until I got older and started seeing other people the way that they are. It was just life."

Tears welled up in Bama's eyes when I asked her what advice she would give a newly diagnosed person. After a pause, she sobbed, "Learn to be patient with yourself. I think the hardest thing is—when you're by yourself and you fall or something—is knowing that you need someone to help you. I used to be an independent person." She gasped and tried to swallow her tears while apologizing. "It was very hard for me to be patient with myself. Because one day you can walk. One day you can run. And then you can't. And you don't have the power to make it be okay.

"I love Jesus, and I believe that He has a plan. But it's particularly hard at the moment to make yourself believe that there's a plan and that you are cared for. I just try to make sense of it, especially when you're younger and you don't get to do what young people do. You miss out on all the things that life should just give you. I've been married for five years, but it's not long enough. I have an awesome husband. I chose a good one. He's really patient and very kind all the time. If he weren't around, I wouldn't be able to do it.

"There are days, like this morning, [crying] There's days that I just can't move yet. He will move my legs for me so I can stand up."

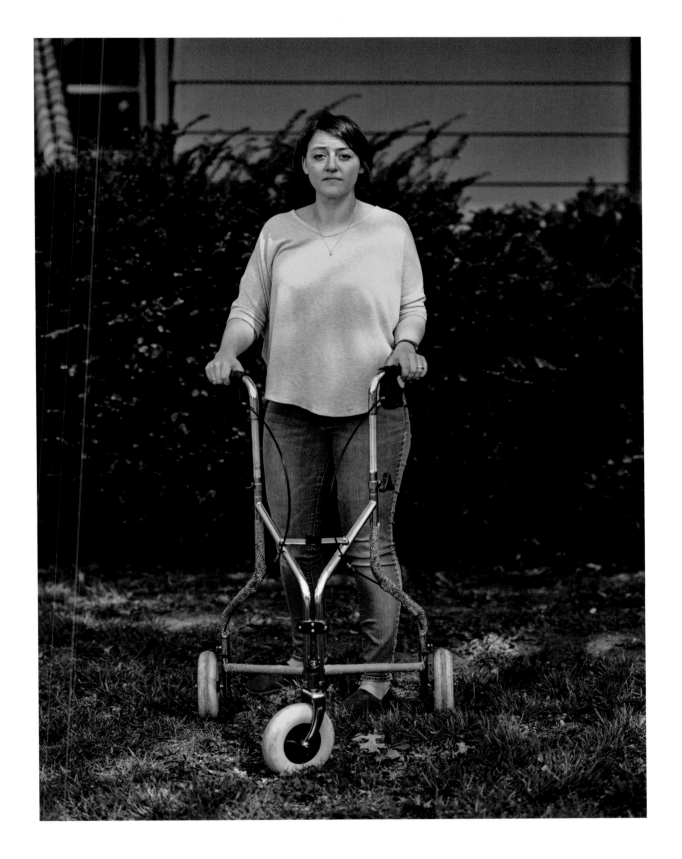

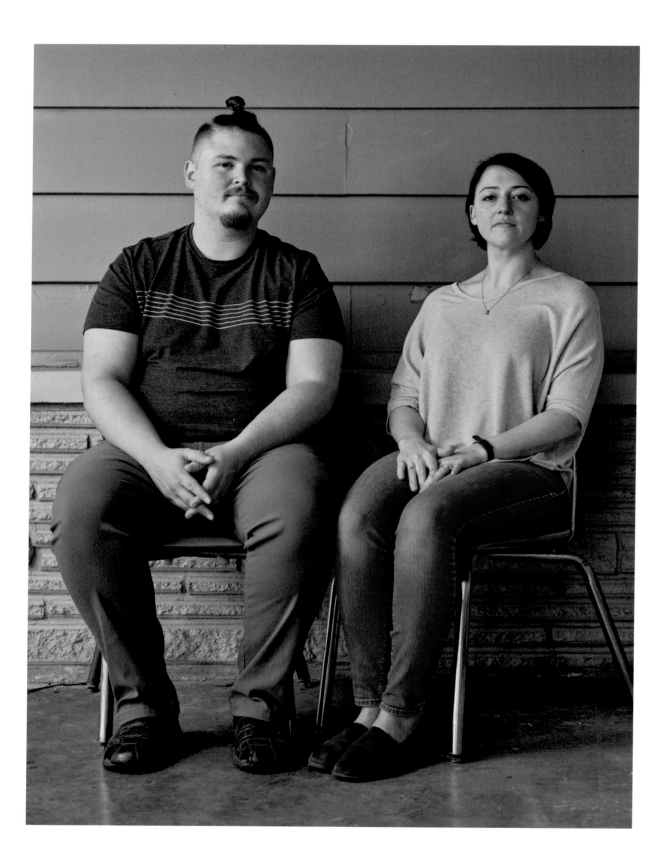

"We went to college together, and I told him, 'Look, you're here or you're not. I could potentially be crippled.' And he's like, 'I'll carry you.' That's how I knew he was mine. He said, 'I'll carry you.' We had a fantastic time in college. We were irresponsible, and all the fun things that you can be at college. Now he does everything. He's my favorite.

"I used to go out a lot, even just on my own. I have my own car, but I haven't driven it in a year, because when I drive, everything seems faster, like the cars going by, and so I don't want to drive anymore. I use a walker now. I used to be a crazy-good athlete, and then I slowly started getting less good at things. I used to love cooking and baking, but I don't do that anymore. Joel does that for me."

I asked Bama about sharing her courage and she replied, "Well, I think also being patient with others, as well as being patient with yourself. Because they do not know what it's like to be you. All you can do is explain to them and be patient—say over and over again, 'I just need a moment,' or 'just let me lay here.' Or telling them that 'It's okay'—because you're not the only one suffering. Everybody around you is saddened by who you're not. It's not fair for them either.

"I love people, and I love being able to make everybody comfortable. I want to make sure that everybody feels comfortable, and if that means I have to say, 'Hey, it's okay,' 'I'm okay right now,' to make them comfortable, I will do that. I don't want to ever be a burden for anyone, and that's the hardest thing."

I asked Bama about her frustrations. She hesitated, clearly uncomfortable not being 100 percent positive, and said, "It makes me angry that there's not a cure or even a medicine that would help me just remember things. I lose the names of simple things, and that's one of the most frustrating things to me. I'm a college graduate, and I worked very hard to get that degree. I'm intelligent, but I don't sound that way anymore. It's stripped you of your youth, and also stripped you of your intelligence. My husband is a very smart man, and we used to talk a lot about things, but it's hard, because I'm not on his level anymore. That's just one more thing to add to the bucket of all this stuff that I can't do anymore.

"It's hard to think about who you were, and now who you are, and be okay with it."

"How do you do that?" I asked.

"I'm still figuring that out. I would say be joyful in every moment, because you might not have another one. If you just go to the grocery store, you can be kind to anybody you meet, and that could change their day. It may be nobody was nice to them, or nobody spoke to them that day, but you can be that person who wants to spread joy.

"I think being patient with people is the biggest thing. It's just knowing that at the beginning of the day people are people and you only have 24 hours to either invest in them or not. You can either make them better or worse, so I think just be good to yourself and to others. That sounds really cliché, but I like that." ∎

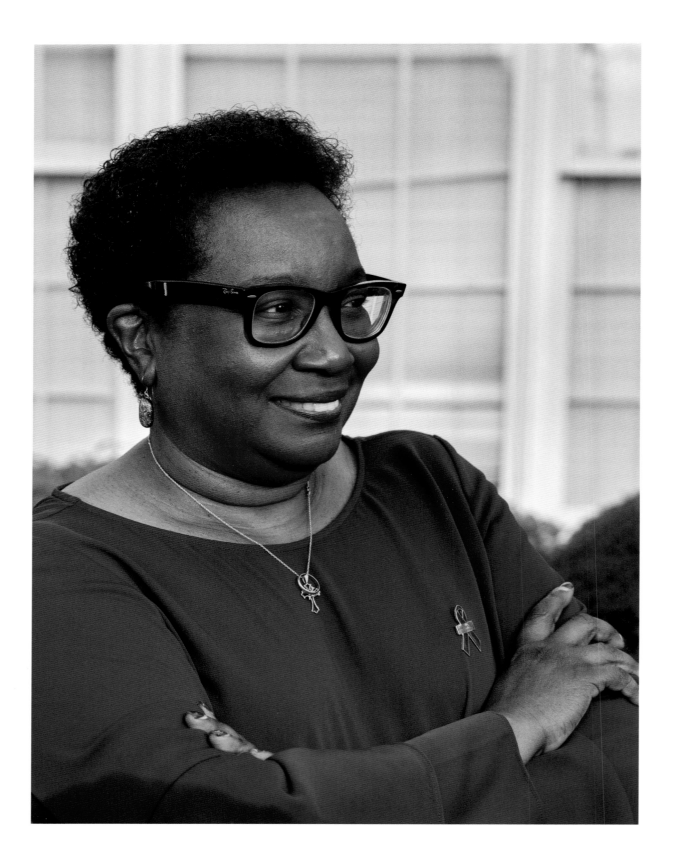

ARTHENA
CASTON

March 23, 2016

'"I JUST HATE TO TELL YOU THIS,' HE TOLD ME, 'You're such a nice person. (I'll never forget him saying that.) You're such a nice person, and you're so friendly and so kind. But I think that we have a problem.'

". . . I knew right then.

"I just sat there. That doctor had a big clock on his wall. You know those Alfred Hitchcock movies? That clock just ticked. It was like tick, tick, tick. That's what it did the whole time he was talking: tick, tick, tick. I just sat there looking at that clock.

"I think my husband said, 'Well, what would you do?' and the doctor said, 'Well, I suggest that you go home and get your house in order, make sure you have all your wills and things together. I probably give her five to eight years to live.' That's exactly what he said. I just looked at him, and I still didn't say anything. He said, 'This is the quietest you've ever been,' and I said, 'What would you want me to say?' My husband said, 'So is there anything that I can do?' The doctor said, 'Alzheimer's is a terminal disease, and she's dying. I'll give you some medicine to try and slow the progression, but I can't stop it. There is no cure.'

"I went through a phase for maybe three months where I was in despair. I was really, 'Oh, my God, this isn't happening,' and then I thought, 'It's no use.' Why continue to be in despair? It's not going to help me. It's not going to make me feel any better.

"I'll never forget, my daughter said to me one day, I was sitting out here, right where you are now, and it's real nice and cool out, and she said to me, 'Mom, why don't you want anybody to know?'

Somebody had said something to her at work—like, 'I heard your mom has Alzheimer's,' or something like that. She knew, but she was a little hurt or embarrassed. So, I called the guy who had said something to her, and I said, 'That's none of your business what's going on with me!' I was just done.

"After a few minutes she said, 'Mom, why are you so angry? When you think people don't know, they already know, so why hide it?' That's all she said. Once she said that, I think about a week or so went by, and after that I called the Alzheimer's Association."

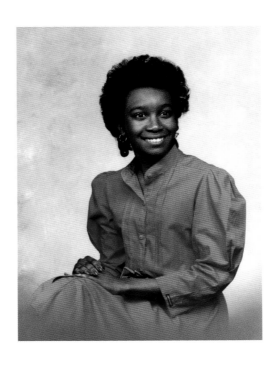

and was diagnosed with younger-onset Alzheimer's disease when she was fifty-one. Her kind and generous spirit were immediately on display when she greeted me at the door of her home in Macon, Georgia, with a huge hug and smile. She introduced me to her husband and invited me inside to talk about her journey with Alzheimer's and her advocacy work.

She recalled how her father and six of his siblings had Alzheimer's. Arthena told me, "African Americans are carrying the disease at a higher rate than any other race right now. Not only am I speaking for the African American side of it or the brown people, but I'm also speaking for women. Women are the biggest caregivers."

Initially, Arthena spoke to local church groups. Soon she was speaking all over Georgia and recently became a member of the National Early-Stage Alzheimer's Advisory Group.

She told me, "I tell people in the beauty shop, in the barber shop, in the ice cream shop. Just because you've got a diagnosis of Alzheimer's does not mean that your life is ending. It's just a different step. That's it. There is no reason to be ashamed of what is happening to you. You did not go out and ask for Alzheimer's to come in your house and jump on you. You didn't ask for that. You did not ask for a doctor to say to you, you're dying. I want people to know that you can live with Alzheimer's. I need people to know that.

"You know what? I'm going to be out there every minute of every day. Any time someone calls me, I don't care who it is, I don't care what it's for. If it's something for Alzheimer's, I'll say yes."

I asked Arthena if she was proud of her advocacy work and she responded, "It feels special. Because you know what? At some point in time, somebody's going to say, 'what does Alzheimer's mean? What was that disease?' I may not be here to hear that, but it is coming. It's coming. I want my grandchildren to not even know what that was.

"My father was a fighter. My brothers and sisters are fighters. We are not people that give up. I'm not going to give up, because who knows? I might give up, and then tomorrow they get a cure, and I'm not a part of that cure, because I gave up. There's going to be a cure one day. Again, I may not be a part of it, but I definitely will be pushing people to get there. That's what I want. That's what I want." ■

BE STRONG IN THE BROKEN PLACES

by Greg O'Brien

ALZHEIMER'S IS A DISEASE THAT CAN TAKE twenty years or more to run its serpentine course. Experts say the pathology in the brain can begin when one is in their forties, without noticeable symptoms. Disabusing the false stereotypes, no two patterns of Alzheimer's are alike, and that confounds the researchers and acerbates the race for a cure. In short, one doesn't get Alzheimer's the day one is diagnosed, just as one doesn't get cancer at the moment of diagnosis. It's a journey in progress. A son or daughter who says their parent died of Alzheimer's five or six years after a diagnosis, likely means that their mother or father was silently suffering from the progressing symptoms of Alzheimer's for as long as two decades.

I know firsthand of the stress. Alzheimer's has devastated generations of my family tree. My maternal grandfather, my mother, and paternal uncle died of Alzheimer's. And before my father's death, he too was diagnosed with dementia. I was the family caregiver for my parents.

Now Alzheimer's has come for me.

My mother, Virginia, was the hero of my life. She taught me how to live with Alzheimer's and when asked, I promised her that I would write with candor and vulnerability to destigmatize Alzheimer's and other forms of dementia. An articulate, brilliant, and beautiful woman, my mother taught me by her courageous example, in her fight with Alzheimer's, that when the brain fails: write and speak from the heart, the place of the soul. As it was with my mother, my brain used to be my best friend, now there's no chance for reconciliation. Has anyone ever asked you: "Tell me what's in your heart, speak from it?" A poet writes from the heart, not the brain. And in Alzheimer's, we all strive, as we can, to speak from our hearts.

I was diagnosed about nine years ago with Early Onset Alzheimer's after experiencing the horrific symptoms of short-term memory loss, inability to recognize individuals and places that I've known all my life, difficulty completing simple tasks, terrible judgment, confusion with time and place, hallucinations, withdrawal, and challenges

with problems. A battery of clinical tests, brain scans, and a SPECT scan confirmed the diagnosis. I also carry the Alzheimer's marker gene APOE-4, which is on both sides of the family. The diagnosis came two weeks after I was diagnosed with prostate cancer, which, in consult with my doctors and family, I am not treating. It is my exit strategy.

Stephen King could not have designed a better plot for a sickness that slowly steals the mind, then pilfers the body, then robs your finances, pushing families, like mine, to bankruptcy. Then, there's the depression that seems to have no bottom, and the flirts with suicide.

Yet Alzheimer's can't take your soul.

So please don't be fooled by the inaccurate stereotypes of this disease. There are millions of individuals living with Alzheimer's in the early stages, still highly functioning, perhaps not even diagnosed yet, who are fighting off horrific symptoms daily and beyond the observations of others. Our minds, in many ways, are like i-Phones— still sophisticated devices, but with a short-term battery that pocket dials and gets lost easily.

Those on this journey aren't stupid; we just have a disease that at times, often without notice, takes us down, dramatically diminishing, more and more, our ability to function. This is a disease that will devastate the Baby Boom Generation and generations to come, if something dramatic is not done to halt its assault.

I will never forget sitting in the neurologist office outside Boston, side by side, with my wife Mary Catherine, listening to the diagnosis. I felt as though I was slipping into Lewis Carroll's Alice in Wonderland where, "nothing would be what it is, because everything would be what it isn't."

What "would be" was devastating. I felt the tears running down the sides of my face. My eyes didn't blink. I reached for my wife's hand, and asked:

"What about the kids?"

Alzheimer's IS about the kids: your kids, my

kids, your grandchildren, my grandchildren. And we need to do something about it.

So where am I today? Sixty percent of my short-term memory, at times, can be gone in thirty seconds. More and more, I don't recognize people I've known all my life; I experience penetrating, horrific hallucinations; fly into inexorable rage when the light in the brain goes out; I have a debilitating loss of filter, loss of self, incontinence, loss of judgment and time and place; also an intense at times numbing of the mind and body, and incredible withdrawal from friends and family. I also have little feeling in both my feet up to my knees and sustain blackouts with the right side of body collapsing without notice—neuropathy, complicated by brain signals that are not connecting properly. In addition, I have acute spinal stenosis and scoliosis, a condition accelerated by the breakdown of the body.

Then there's the depression, the black hole that has no bottom, which often pushes one to the brink of a booster rocket to the planet Pluto.

Like Cancer and AIDs earlier, and Alzheimer's today, depression is taboo—too messy, we can't talk about it. Yet depression is as common in Alzheimer's as forgetting a name. Alzheimer's is not just memory loss, it's a slow, yet complete breakdown.

Years ago, I thought I was Clark Kent, Superman, an award-winning journalist who feared nothing. But today, I feel more like a baffled Jimmy Olsen. And on days of muddle, more like Mr. Magoo, the wispy cartoon character who couldn't see straight, exacerbated by his stubbornness to acknowledge a problem.

The "right side" of my brain—the creative, sweet spot—is intact for the most part, although the writing and communication process now takes exponentially longer. The left side, the area of the brain reserved for executive functions, judgment, balance, continence, short-term memory, financial analysis, and recognition of friends and colleagues, is, at times, in a free fall.

Doctors advise that I will likely write and communicate with declining articulation, until the lights dim, but other functions will continue to ebb, as they are now. Daily exercise and writing are my succor to reboot and reduce confusion.

Daily medications, the legal limits, serve to slow down the progression of the disease and to help control the rage on a day when I hurl the phone across the room—a perfect strike to the sink—because in that moment I don't remember how to dial, or when I smash the lawn sprinkler against an oak tree in the backyard because I don't recall how it works, or, when in winter I push open the flaming hot, glass door to the family room wood stove barehanded to stoke the fire just because I thought it was a good idea, until the skin melts in a second-degree burn. Or, simply when I cry privately, the tears of a little boy, because I fear that I'm alone, nobody cares, and the innings are beginning to fade.

Alzheimer's indeed is a sickness that runs in circles and eventually meanders in for the ultimate kill. It's analogous to the prototypical arcade game Pac-Man in which a pie-faced yellow icon navigates a maze of challenges, eating Pac-dots to get to the next level. While the iconic video game was designed to have no ending, there are no "power pellets" in Alzheimer's to consume the enemies of ghosts, goblins, and monsters, as my Pac-Man in slow motion consumes brain cells, one by one.

Game over!

Not always so, if one is willing to fight in faith, using gut instincts, and with the help of loving families and caregivers.

We learn legions from the words of others. The iconic poet Robert Frost once observed: "In three words I can sum up everything I've learned about life: It goes on."

The only way to face this demon is head-on, through faith, hope, and humor, as this disease robs self-awareness, diminishes function. Empathy is the pathway to understanding and compassion and gives power and purpose to address this burgeoning health crisis.

In the last year, I've lost six close friends to the demon Alzheimer's, now multiply that number around the world. Lots of spouses without mates, children without parents, grandchildren with fewer loved ones to hold them.

Perhaps Ernest Hemingway said it best when he observed, "The world breaks everyone, and afterward, some are strong at the broken places."

Be strong in the broken places . . . ■

A career journalist, **GREG O'BRIEN** is the author of the international award-winning *On Pluto: Inside the Mind of Alzheimer's*. He also serves on the Board of UsAgainstAlzheimer's in DC, is an advocate for the Cure Alzheimer's Fund of Boston, and has served on the Alzheimer's Association Early Onset Advisory Board in Chicago.

WILLIAM FOGGLE

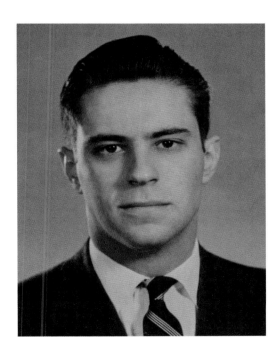

grew up in Springfield, Massachusetts. He attended Dartmouth College and joined the army upon graduation. After the army, Bill returned to Springfield, got married, and joined his father Jacob (Jack) in the family furniture business.

Jack grew up in Pinsk, Poland, where his father was a ship chandler and operated a ferry on the Pina River. One year before Hitler invaded Poland, Jacob and one brother escaped. First to Argentina, and then to Massachusetts. Bill told me, "When the Holocaust hit, he lost his parents, brothers, sisters, nieces, and nephews. Nobody survived."

Despite this incredible loss, or perhaps because of it, Jack was very charitable and deeply involved in Jewish affairs. Jack taught Bill to maintain his faith and contribute to his community. When asked to define what that means to him, Bill replied, "Love of my country. Love of my family. Love of my faith." He continued, "It's giving . . . being part of a community. It's sharing common goals and interests."

Bill's wife Lynn told me, "Bill was an activist, community dynamo, political supporter, and a strong believer in philanthropy. We entertained six different candidates for President at our home and are big supporters of the Holocaust Memorial Museum in Washington, DC."

"How did you find out you have dementia?" I asked Bill. He paused and said, "You could tell. Things were slowing down." When asked if he had a sense of regret or fear, he replied, "No. I take life as it is and accept it. Work around it if I have to. I tried to beat it. If there are things you can't control, you can't do anything about, then go to the next."

Smiling, Lynn added, "Bill's such an optimist. Each time someone calls to ask how he's doing he replies, 'I'm getting better!'"

I asked Bill what advice he would offer newly diagnosed families and he replied, "I think it's a responsibility to somehow let it out. But I understand why people who have this do not. I think

that's an important part for me. I have accepted what I have. There is nothing that's going to change it. Or change it back. Or improve it. I'm very sad about it. But is it better than being dead? Because that's the alternative . . . I'd rather stick around!"

Lynn added, "A concerned friend suggested that I consider taking an anti-depressant. I said I'm not depressed. I'm incredibly sad. This is a stinking ending to what was a great marriage." After a long breath, "It's just sad. I swear on a stack of bibles that I'm not depressed. I'm just incredibly sad that this is the ending. I used to see us, in my mind's eye, walking off holding hands into the sunset. And it's different. It's not the ending I dreamed of."

When Lynn walked out of earshot, Bill told me, "I'm really not afraid of what will be. But I'm sad about it. I'm going to try and fight through."

At that moment their grandson Ethan arrived for a visit and the atmosphere was transformed as if a beautiful sunrise had illuminated the room. Warm embraces, smiles, and laughter filled the kitchen. Conversation about family, fond memories, and gentle prodding about job prospects ensued. Bill and Ethan were eager to watch football together. As I lingered by the door, I turned one last time to see the wheel of life turn—undiminished by dementia. An unbroken legacy of love of community, family, and faith. ■

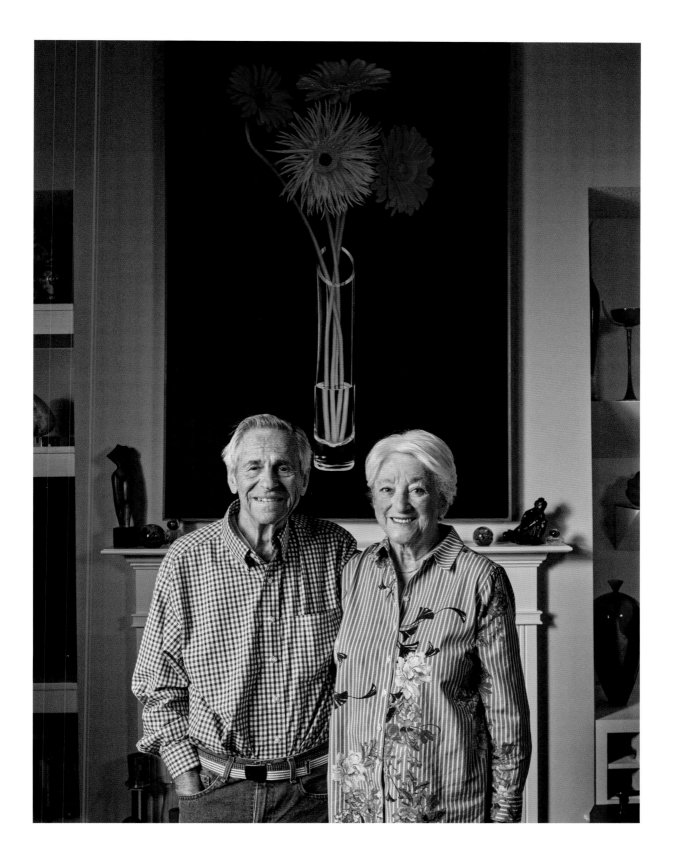

MIKE
BELLEVILLE

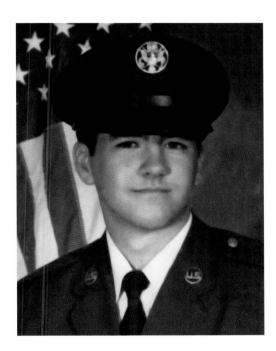

younger-onset Alzheimer's disease in 2013 at age 52. He candidly recounted sitting in the doctor's office with his wife Cheryl, feeling overwhelmed and scared. Mike described the deep sadness and depression that immediately followed.

For Mike, building up the courage to join a group of other individuals with dementia has been the most important step he's taken. Initially, there was relief and camaraderie knowing he was not alone. Then solace and understanding came from sharing experiences within the group. To illustrate his determination and unwavering spirit, Mike uses his favorite quote from Stephen King's *Shawshank Redemption*. The main character Andy turns to his friend Red and says, "I guess it comes down to a simple choice, really. Get busy living or get busy dying."

Today, Mike is a sought-after dementia advocate and speaker. He has given hope and courage to thousands of people with dementia and their families. He's done work with the Alzheimer's Association, Dementia Action Alliance, and Dementia Alliance International, among others.

Mike told me, "The biggest thing for me is stigma. It's because of what people think or what they anticipate. What they 'see' as dementia. The public narrative is tragedy.

"As soon as you get a diagnosis you are automatically put in this pool as a person who is not capable of anything anymore. It's automatic. It's like pow! You are in this bucket now. You're no longer capable of making decisions for yourself. You're no longer capable of participating. You're no longer able to contribute to society. You can't learn anything new anymore. There are all these things that you can't do anymore. It makes me very frustrated and angry.

"When the neurologist sat me down. He explained what the test results showed. He said, 'We're pretty sure you have younger-onset Alzheimer's. I'm going

to start you on this medication. I'll see you in six months.' And he walked out the door. That was it. No referral to support groups. No, 'Here's what you can expect next.' Nothing. If you're given a cancer diagnosis, it's the first thing they tell you! You're plugged into these networks of help and support. For the majority of people with dementia, you get nothing. What is it about this disease?

This needs to be talked about. In the elevator. In schools. In the line at the grocery store. At the family dinner table. It needs to be talked about. No more hiding it in the back room.

In the past this was taboo and scary. You know? And all the words that go with it 'demented,' 'senile,' all that stuff. Today there are a lot of us out there trying to say no. It's no wonder people don't want to talk about it. They are being ostracized. Judged. Assumed to be not capable. And it's no wonder because of what people see in the media. I say don't pigeonhole me. Don't automatically assume I can't do something.

"When I was diagnosed, the doctors told my wife I would be in a nursing home in three to five years. That was six years ago. My point is from point A to point B what are you going to do with your life? You can choose to just sit there and let it run its course or you can choose to do something. Still live a good, meaningful life. For me, it's to show people that you can still learn. You can still contribute. You can still be part of society. And that we deserve, and have a right, to be part of that."

I asked Mike what he hopes his advocacy work will accomplish, and he told me, "I want people to understand that you can still live a meaningful, purposeful life with what time you have. Don't believe the narrative that life is over. I want my voice to help get people to treat us the same as they did before we got the diagnosis. We may change some, but we are the same people. TALK TO US! WE ARE STILL HERE!"

Mike quoted *Shawshank Redemption* once more, "Get busy living or get busy dying." And then added, "Make a choice. Yes, you have this—but it doesn't end tomorrow." ■

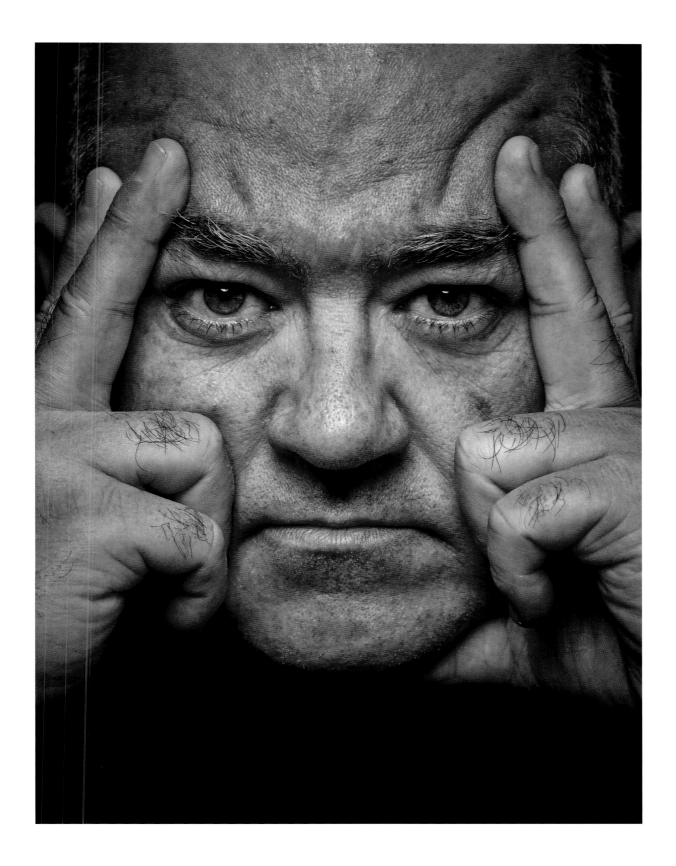

CARRIE + BRYAN

Excerpt from an advocacy speech given in 2015
by Carrie Salter-Richardson

MY FATHER WAS DIAGNOSED AT THE AGE OF 36 with dominantly inherited Alzheimer's disease. He had already lost his mother and two of his brothers. He and his younger brother were diagnosed about the same time, and for seven years, I watched my dad and my uncle slowly wither away. On August 22, 1996, my father turned 43. A friend drove me to the nursing home to take him balloons and wish him happy birthday. I struggled with my faith as a young teenager but on that day, I prayed to God for my father's death. I knew when I left there, it would be the last time I would see him alive, if that's what you want to call it. My dad died the next day.

We didn't really speak about Alzheimer's again until 2009 when I got a call from a long-lost relative letting me know that my oldest cousin had been diagnosed and was already in a nursing home. He died two months later at the age of 37. After his death, we began to do some research and discovered DIAN or the Dominantly Inherited Alzheimer's Network. They helped us determine that our family carries the PSEN1 gene, and we enrolled in an observational study at Washington University in St. Louis.

As part of the study, we were offered genetic testing to determine if we carried the same gene mutation. My brother Bryan was the first to have the genetic test done. Bryan and I are 18 months apart. We've always been best friends. He was always the best at everything. He excelled at sports and performing arts. He was popular and outgoing and the funniest person I know. When I got the phone call that he had tested positive for the gene, a piece of me died.

On December 4, 2012, I drove to UAB (University of Alabama at Birmingham) to hear my results. I remember sitting in a little room for what seemed like hours waiting for the doctor and genetic counselor. When the door finally opened, I knew my answer. It was written all over their faces. But to hear the words, "It's not good news," took the wind out of me. I showed little emotion while the doctor was talking. I just nodded my head and thought about sitting in that nursing home with my dad. I thought about how I would tell my children. Would they too pray for my death? I knew there were many people waiting for my phone call and hoping for good news. I dreaded making those phone calls.

For a few weeks, I let it consume me, felt sorry for myself, and spent a lot of time crying. But I knew there were three people who depended on me, so I decided to make a lifetime of heart-ache into a quest for hope. I joined a clinical trial through DIAN. I became a volunteer for the Walk to End Alzheimer's, which led me to become a congressional ambassador for the Alzheimer's Association. I've traveled to Washington, DC, to meet with representatives and senators, advocating for more federal funding for Alzheimer's. I've been to the Montgomery statehouse. I'm now the chair of the walk. I don't ever want my children to see me give up. I don't want them to feel hopeless.

It is my hope that my story and the stories of others just like me will start a conversation and

end the stigma that comes along with this disease. Just maybe I can bring a new face to Alzheimer's so people know that it can happen to anybody, not just the elderly. I don't know where my story will end. But I do know that I will never give up hope for a world without Alzheimer's.

2021 Montgomery, Alabama

IN THE SPRING OF 2021, I SPOKE WITH CARRIE and planned a trip to Montgomery, Alabama, to photograph her and her brother Bryan.

Carrie told me, "I was 15 when my dad died, but when he was diagnosed, I was only seven. I didn't understand. Nobody ever really tried to educate us about it. My dad was the last one to die of the kids that got it. After that, we didn't even think about it anymore. We just kind of went on with our lives as far as Alzheimer's was concerned.

"Growing up with my dad's illness—him and my youngest uncle are like Bryan and I, the same distance apart in age—they went through it together. Because we didn't understand the symptoms of the disease, we were really embarrassed by our dad. We didn't want our friends to be around him. We laughed at everything he did and said. It was silly. It's hard to look back and think the last years I had with my dad were me just being embarrassed by him. He played baseball in college. He played minor league baseball for the Phillies. He did a lot of great stuff, but all that we remember now is how his life ended in a nursing home. He weighed 70 pounds on a feeding tube in a nursing home."

I asked Carrie how that experience informed her decision to become a vocal advocate and she replied, "I didn't know how the reactions would be, putting it all out there. Trying to break that stigma. It really helped me heal from the devastation of the news. I think that it showed my kids that I'm not going to just lie down and cry and do nothing. I'm going to try to educate people. Of course, I'm not an expert on the disease at all, but I think the best thing I ever did was to sit down and talk with my kids, because it inspired my daughter Hannah to want to do something about it.

"My oldest daughter is a student at WashU. She's a sophomore. She is working as an undergrad in an Alzheimer's research lab right now. It's really awesome. She's actually my best friend. She's at school now, so it's hard."

I asked, "Does she give back to you with messages of encouragement or hope? What does she say back to you now that she's an adult?"

"She just tells me that she's proud of me, and she'll tell me if I'm slipping up on stuff. She's kind of like a mama bear, but she's a nine-hour drive away. We FaceTime a lot. She calls me every day just to make sure I'm good."

I asked Carrie, "Do you talk to your brother (Bryan) about how you're feeling and how he's feeling?"

"We just make jokes about it to each other, because I feel like we're the only ones that can joke about it. He's very witty. He comes up with some really funny stuff. We don't sit there and have deep discussions about it, because he doesn't think that

he is symptomatic, and everybody else knows that he is, and I'm not going to tell him otherwise. We just kind of interact the same way we always have, which is by goofing off, joking around."

"Does Bryan have kids too?"

"No. He's gay. He never had kids. I'm the only one that had children, which makes me feel very guilty. I do carry a lot of guilt for that, because now they all have a 50 percent chance of developing it as well.

"My mom would have you think I'm about halfway in my grave. She's a hard one to deal with. I give her a hard time, but Bryan does need the help, and she does help me with a lot of stuff too. If I get stressed, she'll do my healthcare and all the things that really frustrate me. For some reason, I get stressed out so easily. She'll do it. She'll fill it out for me. She's helpful, but then she's also overbearing. Maybe that's how all moms are. I don't know.

"I know the differences that are happening with me, and my kids definitely know. They mention it. I do get flustered a lot easier than I used to. I used to be able to manage a lot more things on my plate than I can manage now. Just little things. I try to write everything down in a planner, but then I forget to look at my planner. I do have bouts of crying spells, which is weird for me, because I've not done that before. I won't even know why I'm crying. I'm just crying."

A FEW WEEKS LATER, I WAS ABLE TO PHOTOGRAPH Bryan and Carrie together in the backyard of their mother Mary's house in Montgomery. A few years ago, Bryan was struggling to live on his own and had to move back home from Atlanta. Mary is now Bryan's primary care partner. She helps Bryan with life's daily tasks and helped secure him a job at a local nursery where he can still enjoy work but in a safe and caring environment. Carrie had told me ahead of time that, despite only being eighteen months older than her, Bryan's Alzheimer's is much

more advanced, and he has trouble communicating. I asked Bryan and Carrie what they would tell someone who was newly diagnosed.

Bryan looked at Carrie and blurted, "You go first!" Carrie laughed and responded, "When you're first diagnosed, at that moment you think it's the end of the world and your whole life is crashing down. But it's the complete opposite. It's given me so much more courage and brought me to meet so many wonderful people."

Bryan paused with a sigh and said, "I'm bad at speaking. Sometimes I struggle at work. But I get through it. Pennies and nickels and stuff . . . the register . . . it drives me nuts! You know what I mean? If someone is trying to use a check I have to ask for help. I struggle every day at work. But I still like it. I'm not very good at the computer. I can't type really fast. Sometimes I lose my train of thought. I used to be the wittiest person in the room, but I feel like it's kind of dimming for me. But I can still pull some jokes out." ∎

HANNAH
RICHARDSON

Carrie's daughter and Alzheimer's advocate

HANNAH RICHARDSON WAS A SOPHOMORE
in college when we met on the Washington
University campus in St. Louis. I had previously
interviewed and photographed her uncle Bryan
(forty-one) and her mother Carrie (thirty-nine).
I asked Hannah about her family and her journey
as a young Alzheimer's advocate and now college
student. Because Hannah was so young when her
mom Carrie was first diagnosed, she had to face
the stigma and stereotypes of people living with
Alzheimer's very early.

She told me, "I've had multiple people in
my life tell me that my mom is lying. I've had
people, friends and classmates tell me that since
my mom is so young, there's no way she could have
Alzheimer's. To my face people have told me that,
and it's so hard to deal with that. When that
first happened, I was fourteen and my mom was
already doing some advocacy work.

"I was just shocked that someone would
even think that or say that to me. That pushed
me to follow my mom and try to be more active
in the advocacy realm and to educate people
my age, I started volunteering with my mom,

and I eventually started my own chapter of the
Youth Movement Against Alzheimer's at my high
school. It was really empowering and it kind of
pushed me to want to do more advocacy- and
education-type work.

"It was such a surprise to see how little people
actually knew about it, even into college."

I asked Hannah to tell me about her mother
and how she copes, and she told me, "There
have been moments where I feel so devastated
and defeated by it that it literally breaks me down.
My therapist said, 'It's like grief, like you've lost
someone, but you haven't lost them yet, but you
know it's coming.' To me, I feel that's even harder,
because you're waiting, and also my mom has
been asymptomatic.

"I don't think she's asymptomatic now. She still
does. But in the last few years, I've started to see
those little signs, and those little, subtle changes
slowly happen. It was reality hitting me in the face."

I asked, "What are the little signs that you've
been noticing, because your mother and your
uncle Bryan present very differently?"

Hannah said, "They definitely do. My mom
was asymptomatic until probably about two years
ago. She still tells people she's asymptomatic,
because no doctor's told her she's neurologically
symptomatic. She's not forgetting things. She's not
having the same things my uncle is experiencing,
but I still think she is, because behaviorally she's
not the same person she was. When I was growing
up, my mom loved to be very social. She was always
around her friends. She played tennis. She had all
these different friend groups that she spent time
with. She cared a lot about her friends, and now
she has no friends. She does not see anybody.

"Going to the store stresses her out. Me Face Timing her on the phone gives her so much stress, and she gets overwhelmed by it. Any type of social interaction, if it's more than just someone talking to her in the kitchen, it's overwhelming to her, and she gets agitated and frustrated and just lashes out.

"Three or four years ago, that was not the case. If you try to bring that up to her, she's in full denial of it. It's really hard, because she's definitely interacting with other people very differently than she used to.

"When I go home and when I talk to her on the phone and I see these things, it's definitely really hard, because it's like my mom isn't who my mom used to be, and she doesn't even realize it or acknowledge it. I think that makes it even harder, because if you try to bring it up to her, she denies it and thinks that I'm just pulling it out of thin air, but I'm not, and other people see it too. It makes it a lot harder to acknowledge and deal with it. I think her way of coping is not acknowledging it and not grieving it or being upset about it and just not even trying to think about it happening.

"That's been hard, because I think that was part of why I didn't face reality for so long, because she just tried to help others and didn't act like it affected her. But it does. And it affects her and my siblings. I think it made it a harder journey in that sense, and I wish that she would acknowledge it more. I don't know how to change that, but it definitely makes it harder. I get sad about it and I get anxious about it. I worry for my future because I know that I have a 50 percent chance of having Alzheimer's. I don't want to lose her and lose my siblings. I don't want to die!

"I get anxious and sad, and I've never heard her talk about that. I've had to kind of cope with those emotions and go through that in my own way, because she wasn't there. I didn't see how she did it, and I didn't see how she was doing as something to relate to."

I asked Hannah, "How did your family's history with Alzheimer's influence your decision to study medicine?"

"I saw how in the beginning my mom didn't just shut down when she got her diagnosis but tried to be active in the community and try to educate others. That was really inspiring to me, because she didn't just sit down and take it. I want to do that as well, because my mom's always been someone I've looked up to my entire life, and I just admire her strength.

people from dying from it. Stop people from having to go through it, and watching their loved ones go through it. Because I sure as hell don't want to watch my mom go through it, or my uncle, and I don't want to watch me go through it or my siblings. Knowing there's nothing right now, you just feel so hopeless and helpless. I think that's part of the reason why I want to go into research, because I don't want to feel helpless and hopeless. That is what scares me most in the entire world." ■

"When I was in high school, I started going with my mom to her yearly visits at WashU and seeing what the doctors do. I told them I was really interested in science, and they'd let me go in during some of her scans. They'd tell me about the brain and stuff. It was really cool, and I really enjoyed it. These people are doing work that actually impacts people's lives, and that's something that I really want to do. I got really inspired and thought 'I want to go to WashU. I want to go into research. I want to do what these doctors are doing and help people.' I just focused on that a lot. It's also a way to cope with what my family is going through. I can do this, and it will help, and that will be something I can be doing that's proactive to help my family and other families and everyone in the Alzheimer's and dementia community.

"I think my wish is like everybody else's—I want there to be a cure or treatment, because it terrifies me to think that I could have this. It's the scariest thing I can think of, and I don't want it. All I can hope is that there's something that someone somewhere can figure out to stop this and stop

HELEN TUNG

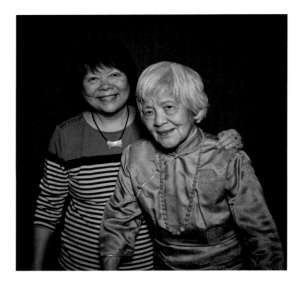

Helen Tung's amazing life or the impact she's had on so many. To start, she was one hundred years old when we met and made her portrait together. Born in 1917, Helen grew up in Liling, Hunan China. For most of her youth, her father was studying in France and then running the family business many miles away in Harbin. Helen's family was displaced when the Japanese invaded in 1932. Later during high school and nursing school, China was again at war with Japan. Despite the war, Helen pursued her dream of becoming a nurse and

midwife. She married just before the end of World War II and, a year later, almost died from typhoid fever. When civil war broke out in China, her husband was sent to Taiwan, with family in tow, to open a bank branch there. Little did they know the Cultural Revolution was beginning in China, and they would not see their parents, relatives, or their homeland again for thirty years! Helen and her husband had five wonderful daughters and she enjoyed a long career as a midwife in Taiwan, delivering hundreds of babies. In 1978, they immigrated to the United States and settled in Philadelphia to be near their daughters.

What amazed me most? When I asked Helen and her daughter Ann about their lives, experiences, and values—I did not hear about the drama and adversity of being separated, living through two wars with Japan, the communist takeover in China, or their isolation in Taiwan. Instead, I heard about a loving, curious, and adventurous family. A passion for cooking, gatherings, and family. A deep sense of faith and a continual thirst for learning.

To say I admire their perseverance and commitment to positive thinking and focusing on what matters most, would be an understatement! ∎

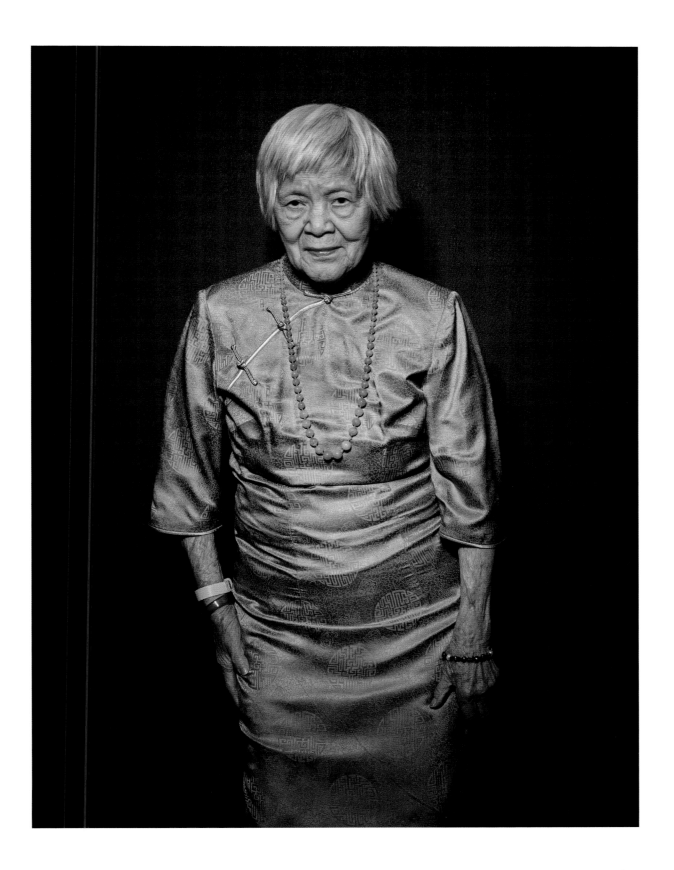

RENEE PERKINS

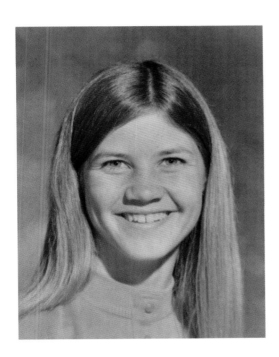

home in the suburbs of Nashville, Tennessee.

Renee has Alzheimer's and is an outspoken advocate for those living with the disease. She was a nurse for twenty years and went on to become an ordained minister. Steve was a Marine pilot, then a commercial pilot for Delta, and now a contract pilot for private plane owners. The first time we spoke, it was immediately clear that we all want to openly share stories and break the crippling cycle of the stigma that people with dementia suffer from.

Renee told me, "My grandmother died of Alzheimer's at the age of 66. Back in the 1980's they called it 'pre-senile dementia.' My mother began getting symptomatic at the age of 59, but sadly remained in complete denial until she was unable to even realize it. She passed away at the age of 77. At the age of 56 I enrolled in the Alzheimer's study at Indianapolis University. A year later I found out that I am a PS1 gene carrier.

"Stigma can often lead people with dementia to have low self-esteem. Studies have shown that stigma promotes social exclusion and a reluctance to seek help. There is even one study that shows negative social stigma can even worsen the actual plaques and tangles of a person with dementia.

"I can remember my grandmother's advancing disease, and the one thing I noticed was how isolated my grandfather became. It seemed like people abandoned him, and he cared for my grandmother on his own until the day she died. Even my mother and her siblings avoided going over until they felt they had to visit out of guilt. My mother may have said something like, 'She can't communicate with us . . . it's not like she is there.' When my mother's own Alzheimer's eventually progressed it would be her husband that felt abandoned by their friends.

"When it was obvious that my mother herself was beginning to get symptomatic, she denied that it was Alzheimer's. She would constantly say that she had just had a TIA (Transient Ischemic

Attack), and that there was nothing wrong with her. I think she feared her mother's fate more than anything.

"Educating ourselves and others that the person with Alzheimer's is still there and is still a person of worth becomes the key of dealing with the negative social stigma that surrounds Alzheimer's."

Steve added, "I guess, education that we can provide to the general public. Friends have stopped contacting us, and even people that I work with. I've lost jobs, because I've said my wife has Alzheimer's, and right away they go, 'Oh, you're not going to be available,' or 'You're not going to be able to do this.' It translates to other family members as well. It's pretty widespread. It's kind of like racism and other forms of stereotypes. It's pretty deep-seeded."

Renee continued, "As my mother's cognitive abilities deteriorated, I worked harder to be more accepting of her for who she had become. We no longer had the same relationship. She was not who she once was, but she was still my mother, and I could learn to love and accept her in new ways. She loved to cook, so I would allow her to do very simple tasks in the kitchen and encourage her. Eventually I would feed her with tenderness, and continued simple conversation with her, even if it

was one sided. She loved music so I would put on her favorite music and sing along. I danced with her when she was still mobile, and gently swung her arms to the rhythm when she was no longer able to stand. I tenderly talked to her, sang to her and touched her at her bedside when she died. I had learned how to have a new and different relationship with her."

I asked Renee, "When you reflect on taking care of your mother and now your own struggle with dementia, what advice would you give a newly diagnosed individual or their family?"

"The first thing to understand is that you are not in this alone. There are support groups in addition to your family and friends. Seek out all the help you can.

"Your loved one is still there; they are just different. Just as there is a difference in a person from infancy through childhood to becoming an adult. In my lifetime I have watched negative stigma and social awareness change about both cancer and AIDS. Together we can change the negative social stigma surrounding Alzheimer's. Education is key to dispelling the ignorance that causes so many to judge or form stigmas regarding dementia. Never lose sight that the person with dementia is still very much a person of value and worth." ∎

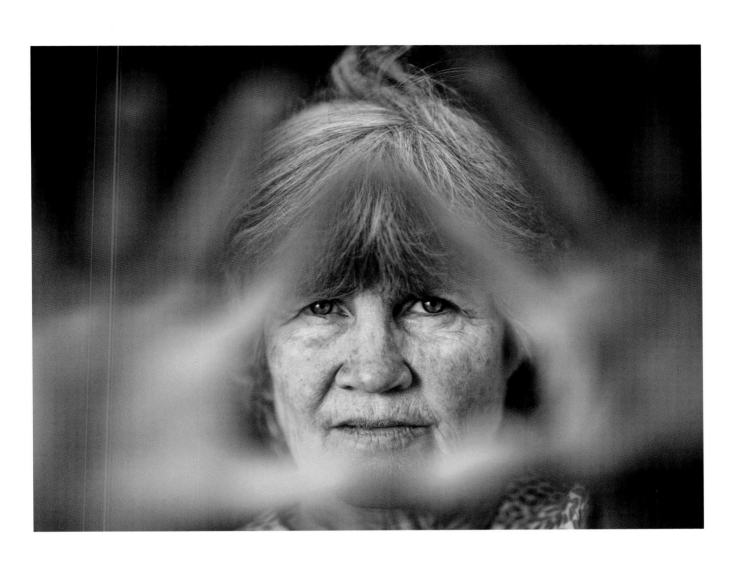

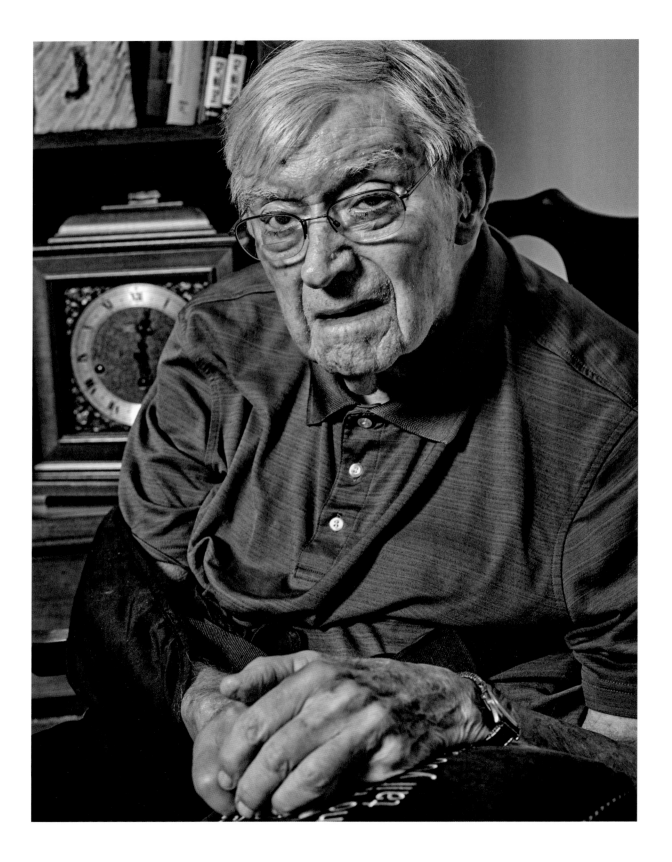

JOHN HUNZIKER

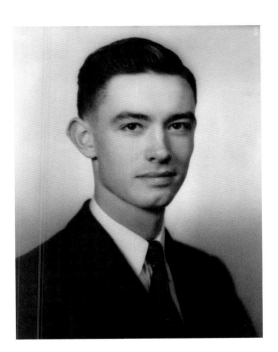

born in Binghamton, New York, in 1932. Eager to serve, he joined the navy at seventeen near the end of WWII. After spending three years studying at Syracuse University, the navy called him back to serve during the Korean War. Following his discharge, General Electric offered John an engineering job, which he held for forty-one years. While enlisted, he met his future wife Anne in New London, Connecticut. They married in 1953 and had two children, Kathleen and David. John's career took him back to Syracuse, then to Oklahoma City, and eventually Pittsfield, Massachusetts, where they lived for thirty years before returning and retiring in New London.

Following his retirement, John spent ten years as a Red Cross disaster relief assessor, traveling to eighteen disaster sites and spending thirty-plus days in relief efforts. John retired again to help manage a wave of chronic illnesses that invaded Anne's life—ulcerative colitis, breast cancer, and then multiple myeloma. During this period, John was diagnosed with Alzheimer's disease, which eventually resulted in the surrender of his license and the pendulum slowly swinging to John needing more managed care than Anne. Several times during her illnesses and long hospital stays, Anne was not expected to survive, but she said that her love and concern for her husband contributed greatly to her multiple recoveries and her desire to help care for him as he had been her constant support through so many trials.

Anne told me, "I could die tomorrow if John died today. My goal is to outlive John. By one day or one hour—and that's why I keep coming back. I'm strong enough to stand by him and I will!"

In 2016, John and Anne downsized from their four-bedroom home of twenty years to an apartment, choosing to give up privacy and familiarity but also to give up the chores, repairs, and expenses. For the last four years, Kathleen has driven down

from Massachusetts and lived with her parents in New London from Tuesday to Friday. She describes the challenge as trying to adjust to their declining physical and mental abilities as opposed to the work itself.

John, Anne, and Kathleen's partnership is extraordinary—their love, honesty, and dedication apparent. Most important of all—they share the clear-eyed goal of living life on their own terms, with dignity and home intact.

I asked Anne how she would translate her journey with John into hope and advice for other families newly diagnosed with Alzheimer's. Her reply was, "Don't do anything different. We carry on like we always have, just with more assistance now. We have dinner at the table. We take part. Sleep in your bed. Dress in your clothes." Kathleen nodded her head and added, "Talk to the patient not about the patient. Don't allow the diagnosis to become or give away your identity." ■

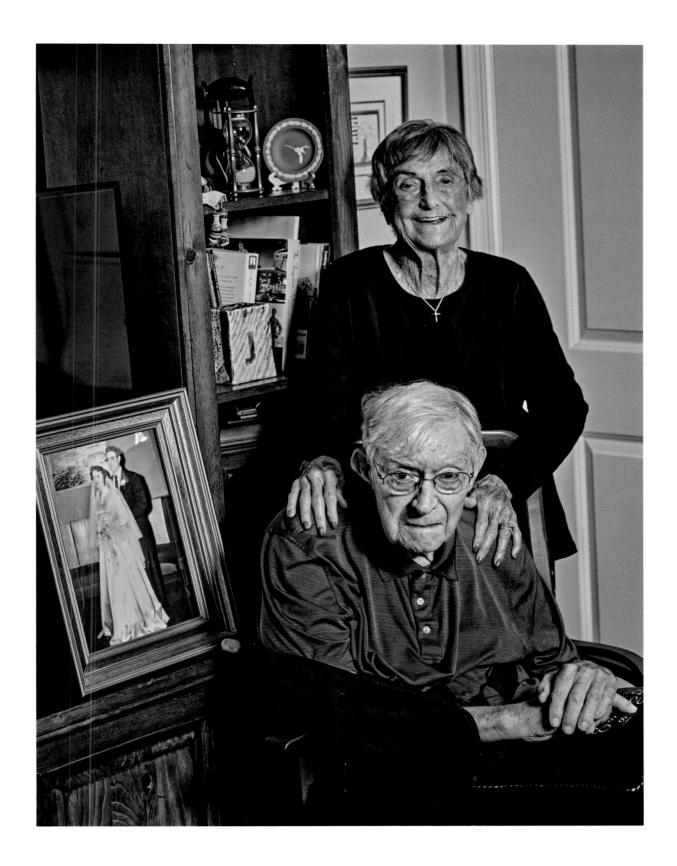

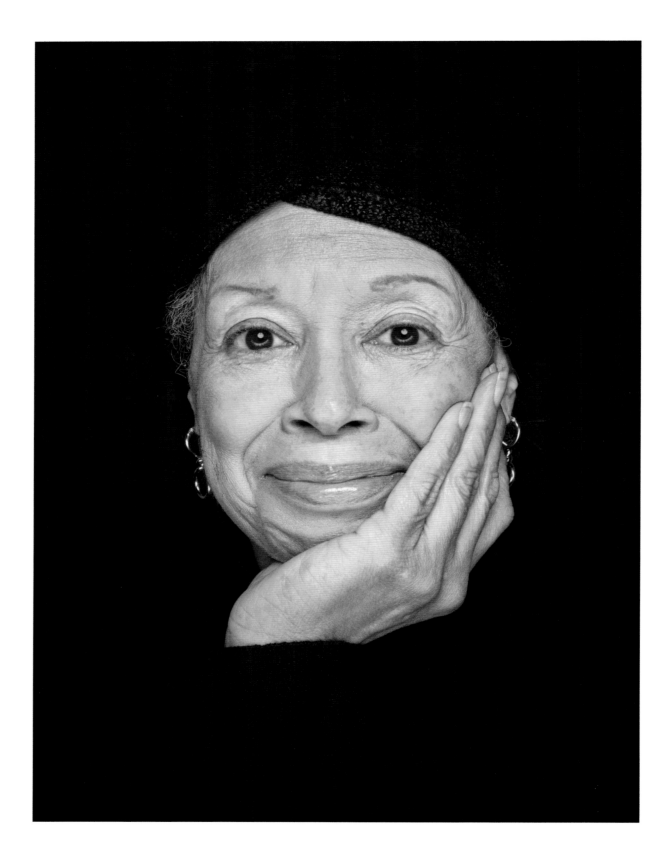

B. J. FOX

THE WARM ENGAGING SMILE. AT ONCE penetrating and somehow hopeful. That's the first thing that drew me to B. J. when I met her. Oftentimes, my subjects are quite nervous at the beginning of an interview. B. J. was the opposite. She perceived that I might be nervous or reluctant to ask certain questions and tried to put me at ease. She told me, "I talk a lot. I love people. You can ask me anything." She treated me like an old friend, certain that we would have a lovely conversation.

Known to everyone as B. J., Barbara-Jean Fox was born May 29, 1940, in Roxbury, Massachusetts. Her parents both grew up in Boston, and B. J. was one of three children. Her parents were active in the community and hosted meetings for a Dorchester women's group. B. J. recalled that one night two members came to the house and asked her parents to take in a little girl whose mother had died. They agreed on the spot. Later, in similar circumstances, her parents adopted a boy whose mother had died in childbirth.

B. J. told me, "My parents adopted two children and I was home with them most of the time. I was like 16 or 17. By that time my brother was in the service. My sister was getting married. I never got married so I took care of the kids and helped my mother with them."

I remarked to B. J. that her parents had set a powerful example of love, selflessness, and compassion.

She slowly nodded her head. Eyes glistening with tears, she said, "I love children. I was really good with them. I get that from my mother and grandmother."

B. J. regaled me with stories of babysitting her adopted brother and sister and how she loved working with children. But when I asked her about her work life, she couldn't recall the twenty-five years she worked at New England Telephone. Only with a friend's prompting did she tell me about assembling the phone books each year. B. J. remembers her birthday but not her age. When we were talking, her mind would get stuck, and she would repeat the same story every few minutes. B. J. described losing her brother last year after a battle with Lewy Body dementia. But when I asked her if she was afraid of dementia, she simply shrugged and said, "I have wonderful friends, I don't need to worry. They will help me." ■

ARTHUR MAZMAN

Mazman was born at home in Lynn, Massachusetts, on April 24, 1931. His parents Melina and Missak came to the United States in 1918 to escape the Armenian genocide.

Missak owned rental properties in Lynn and a candy store. When Art was seven years old, one of the tenants got into an argument with Missak and beat him unconscious in the front yard. He died at home from his injuries the next day.

Arthur clearly remembers having the wake and viewing in their house. He told me that for years afterward, no one in the family wanted to be in the living room.

Art described how all his brothers worked as teenagers to help pay the bills at home. Art worked with his brother Albie in the kitchen of the Towne Lyne House in Lynnfield to help pay for college. He studied electrical engineering at Wentworth and then worked his whole career at Stone & Webster.

Art exclaimed that he didn't know how Yaya managed to raise all the kids by herself (Melina's nickname was "Yaya"—Armenian for grandmother). But then he quietly said to himself, "Yaya was tough. She was tough as nails." His niece Melanie told me, "Yaya was a presence even though she was 4'11" and barely spoke English. I think she was very tough on her kids but that actually made them appreciate her more. All my aunts and uncles are very giving and would give you the shirt off their back if you needed it."

Art loved to paint, cook, play tennis, and travel. Giving sketch pads and paints as gifts, he shared his love of art with his nieces and nephews.

Neither Art nor his older sister Isabelle ever married, choosing instead to live at home with Yaya and take care of her until she died in 1985. Art and Isabelle bought a home near the beach in Swampscott, which they shared until Isabelle passed away in 2011. At eighty years old Art was

living alone for the first time. Just like with Yaya, as Art started to show signs of dementia and his health began to decline, the family rallied to do everything possible to let him stay home and out of institutional care.

His brothers Harry and Albie visited often. His nephew Ed came by after work almost nightly. His niece MaryEllen is a constant presence in his life—facilitating all his doctor's visits, finances, and in-home nursing care. Eventually another niece, Anita moved back from Florida to take on the responsibility of being his daily caregiver.

As we sat and talked about the family tradition of gathering for Christmas and Easter (for over sixty consecutive years), I was curious to note that Art kept a tissue wrapped tightly in his hand. I quickly learned Art often has tears of joy and keeps the tissue at the ready to catch them. First, he cried a bit when his niece Melanie entered the room—overwhelmed with gratitude and happiness simply by seeing her smile. Later in the conversation, he wept when we discussed his brothers and sisters. He said, "I'm so lucky. I have a great family. They were all terrific."

Dementia may sometimes prevent Art from remembering names. He may confuse time or certain details. But his deep connection with his family and his gratitude for them are undiminished. Art clearly feels that family is forever, and the comfort he receives from that love is palpable. Each time he sees family, out come the tears and the tissue. Family—the most powerful tonic. ∎

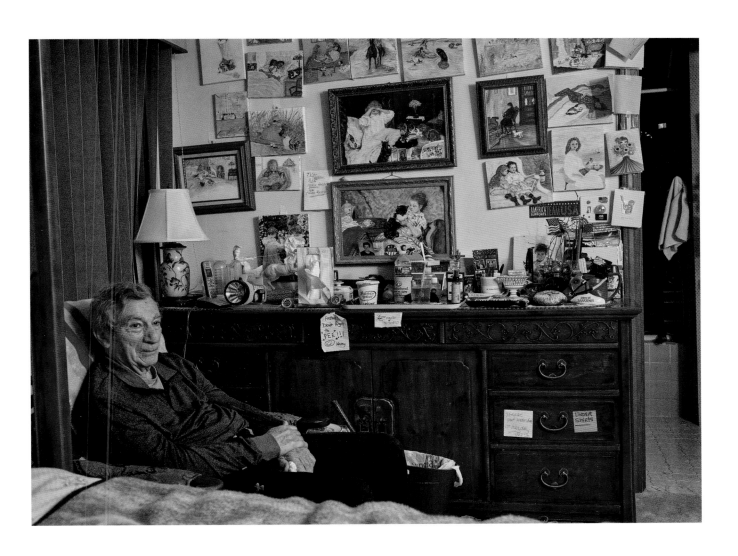

ANDRES MARTIN

"MY FATHER DIED IN 2012. I WAS STATIONED IN Hawaii at that time. Within weeks, my sister sent me an article about the Jalisco mutation written by Dr. John Ringman at USC. It was about a family from the same region of Mexico as my family who had the same symptoms, same timelines. That article is what brought to light what was going on with my family. I was scheduled to move to California at that point, so it aligned. As soon as I got to California, I did genetic testing with Dr. Ringman, and from that, I found out that I'm positive for the Jalisco genetic mutation. It's guaranteed that I will get Alzheimer's."

Andres Martin is a Marine helicopter pilot. He's currently stationed at Walter Reed Medical Center to receive treatment. On a humid spring day, he and I sat at a picnic table at Hains Point in Washington, DC, watching his wife Amanda play with their young daughter Alexis. I had sought out Andres for his unique perspective—he knows he will have Alzheimer's disease but not when he will begin to experience symptoms.

The "Jalisco mutation" is a genetic mutation affecting people from that region of Mexico and is linked to younger-onset Alzheimer's. Andres said, "My diagnosis answered a lot of questions. It answered why my father began to lose his memory in his 40s. Why he got lost on simple driving routes, and why he eventually passed away at the age of 51."

I asked Andres about his move to Walter Reed and what kind of support the marines had offered. He told me, "In my career, there's a lot of sleep deprivation and stress. I had started taking medications for a trial, for the DIAN trial (Dominantly Inherited Alzheimer's Network) back when I was at Camp Pendleton, and for some of those medications, there were unknown symptoms. That's kind of the way I got grounded from flight. They were supportive. They helped me get to Walter Reed. I've been fighting for medical retirement, so I will have all the medical benefits getting out."

Together with Dr. Ringman, Andres helped organize a conference that brought Alzheimer's experts to Mexico to discuss the disease.

He told me, "I just feel like the only thing I have control of is my words, my advocacy. I'm not a doctor. I'm not a scientist. I can help get people involved, greater awareness, and get them into trials, which helps me out in the long run, so that's my focus."

I asked Andres, "What would you tell somebody else who's just realizing they have a family history or is in your shoes with a rare genetic mutation?"

"I think mental health is a key part of this. My way to stay mentally sane is by knowledge. Know enough so that you can focus on your normal life instead of thinking about Alzheimer's 24/7. I already know that I'm in the correct trial. Okay, as soon as they get a medication, it's available to me. I already know that if I sleep well, it's going to help my brain recover. I already know that if I'm not stressed out it will help keep my mental health. I already know, hey, I'll do some brain games a couple of times, so I'll learn something new, neuroplasticity.

"The main goal is to live with Alzheimer's. Don't let it drive you. Be informed enough to be patient and comfortable with normal life. We've been advocates for that, and we've been applying that philosophy, and it's been working for us.

"Everything should be for the next generation. You might be scared but the most important thing in life is your children. Everything we're doing is so that Alexis doesn't have to deal with the hurt that we have to deal with. If my involvement and participation help me live longer, it's a plus, but everything's for Alexis.

"I don't think I have time to feel sorry for myself. I don't think we talk about Alzheimer's very often. Birthdays, sometimes it's tough. You know what I mean? It's not like we sit down and wallow.

"There was a lot of backlash when we did the article with the *Washington Post*, people were saying, 'Why would you have kids if you know they're going to be sick? You're pretty much giving them a death sentence.' But, at the end of the day, one of my uncles in Mexico said to me, 'Hey, if your dad would have known about this and he didn't have you, you wouldn't have had 33 years of life, your daughter, your wife, being a pilot.'

"We're going to continue to go . . . to keep going." ∎

BONNIE ERICKSON

call with a group of her friends—all of whom are living with different kinds of dementia. It's a fun, outspoken, and supportive group that meets weekly. One of their members asked me to join and share my portrait project with the group, and I've since interviewed and photographed several members.

Bonnie and I spoke again a few weeks later in May 2021, and I traveled out to her home state of Montana in August to meet and photograph her.

"I'm 60. I was 57 when this all started.

"We were camping in 2017, I noticed my leg was numb and I was holding my hand all day. I've had carpal tunnel in the past and I thought it must be back. Monday morning I went to work, and I couldn't type. It was the weirdest thing. I just couldn't type. But I wasn't putting anything together. I went to see my doctor about carpal tunnel. He examined my hands, took my blood pressure and then said 'You know, we're not going to talk about your carpal tunnel today. I think you need to go across the street to the hospital.' I did, and I was immediately admitted. They did a scan and said that I had had a stroke, and my blood pressure was out-of-control crazy.

"I was only in for a couple of days. I had some stuttering issues and left side deficits. I went back home and cried because I'd had a stroke, and I was only 57. 'Shoot!' I thought. 'Well, if this is all it is, I can manage this.' I went back to work. I didn't take any time off, which was not bright. I had an appointment with a neurologist a few weeks later and he also ordered an MRI. Nobody in the hospital told me this, but when I went to this neurology appointment, my daughter was with me, and, yes, I'd had a stroke, but I also had an ear problem in 2014, so he was comparing images.

"He said, 'I want to show you this,' and I had what he called white-matter disease. I didn't know what that was, and he said it was multiple little

strokes, and with white matter it's subcortical, so it's in the deep, fine, hair-like vessels of your brain. He said, 'Go live your life.' I asked, 'Can you count them?' and he said, 'No, because it starts to be all white, so you can't tell how many.' My daughter and I left, and we thought, what the hell? 'Go live your life?' What does this mean?

"We started researching, and we started to panic more and more. Even on the Alzheimer's site, vascular dementia is secondary to white-matter disease. I went back to my internist, and he set me up with a cognitive test. At that time, I think he coded it MCI (mild cognitive impairment), but said, 'MCI, dementia, early stage, what's the difference?'

"I fell into a deep depression. I was still working, or trying to, but my work was just piling up. Going through the whole grieving process, anger, denial, depression, was so difficult. I just hadn't gotten to the acceptance part.

"My cardiologist sent me to the Mayo Clinic in Minnesota. That's an amazing experience in of itself. It's like a well-oiled machine. I went on a Wednesday. They asked me to stay several days for all these tests, and, ultimately, same conclusion, with no real answer on life expectancy.

"I worked for the Department of Homeland Security in Montana as an analyst for 15 years.

A year after my diagnosis, my physician took me off work indefinitely. I cleared out my office and left work forever. Then came the stress of dealing with the government to get disability. Social Security came through fast, because of the compassion law.

"After 18 months of just pure hell and crying myself to sleep, I was still suffering from the symptoms of my stroke. I stuttered terribly. I was going to PT for my arm and my leg, and I was going to speech therapy. I wish they wouldn't call it speech therapy, because that just sounds like talking. I wish they would call it cognitive therapy. I was going there every week, and it actually, really helped. I think my brain did some rewiring from that frontal-lobe stroke. It took until 2019 to kind of get my shit together, so to speak. It took a while to get the whole speech and stuttering thing put together, to include word finding, and memory issues. I lay in bed in the mornings and play a little game called try to remember what you did yesterday. I hate it. I hate this. I hate that this is even happening, I hate that the game is so difficult.

"I was just feeling the sense of it's sort of a catch-22, because people in general don't know much about dementia, hence you don't get the support that you need. I quickly decided I was just going to try to hide it, that would be easiest for family and friends. Pretend like everything is fine, even though inside my brain it was far from fine."

I asked Bonnie, "What's the hardest part?"

"The hardest part is knowing you were somebody else, and you're not that same person anymore. People like to say, 'Yes you are. You're the same person, this is just your new normal.'

"Well, I don't like my new normal. This is not what I would have picked. You know, deep inside, how much you had it together. You also know how much you don't know.

"Friends and family used to call me the entertainment director. I would book the disco bus at Christmas time and invite 30 people, and we'd all go look at lights. I'd have Kentucky Derby parties. I'd have a shrimp boil in the back yard and have the big tent set up. This year it was just my family, because I don't do well in big crowds anymore. Talk about high anxiety!

"My brain change has caused some pretty crazy stuff. One time I was driving, and I was a block from my house, and just for a brief moment, I didn't know where the hell I was. I drove really slowly, looking at homes and not recognizing them or where I was. These are homes that I drive by all the time, this experience was really, really freaky. I think dementia is probably like mini acid trips for some people. Just crazy.

"It's the isolation. It's the knowing who you used to be, and you know you're not anymore. The days go by. You get up in the morning, and then you look, and it's 9:00 at night. You try to think, well, what did I do all day? What used to take ten minutes takes forever it seems. I now have a mystical relationship with time. Most people think that living in the moment sounds delightful, calm and serene. It's not . . . it's simply living in the moment without clarity of future or past.

"It's just really bizarre. I even tell my doctor, 'I just feel like I'm high or in a fog all the time.' Off-balance. It's just really bizarre, and you just don't want it to be. You want clarity. You can't have it.

"I want to tell people that if they have a loved one, a friend, whoever, that is newly diagnosed, treat them with compassion and surround them like you would any other person with a devastating diagnosis. Don't ignore it. Embrace them. 'What can I do? How can I help?' Check on them regularly. Getting a diagnosis is just so stigmatizing. Self-stigma is there too. I instantly thought I didn't have much time, and I thought I would be at end stage in no time. I didn't know that there was all of this living to do between point A and point B, and I'm grateful for that." ■

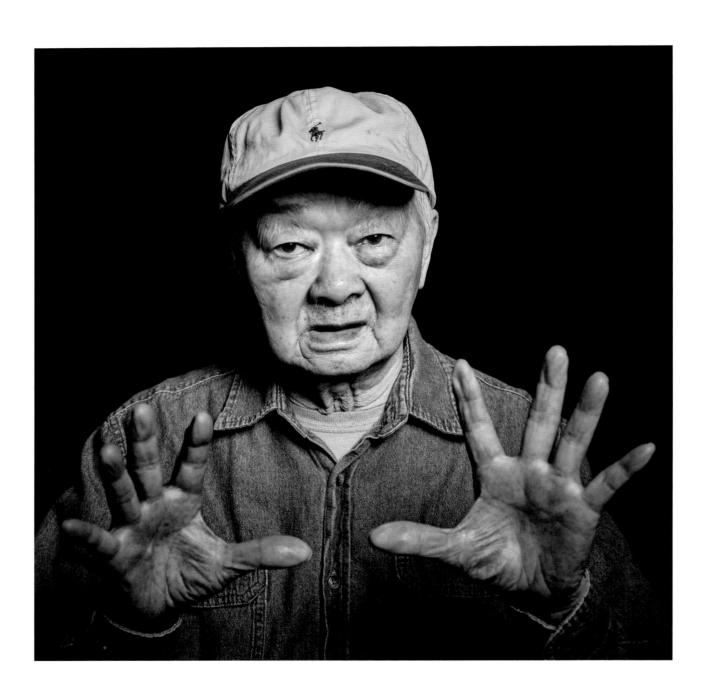

PAK HUP TOM

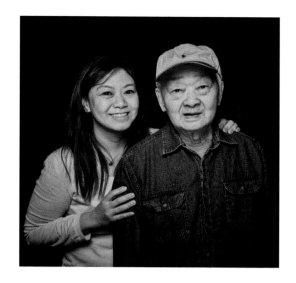

PAK HUP TOM WAS BORN IN TOISAN, CHINA, in 1932. He and his wife immigrated to the United States in 1967 and had three children who spent their early lives in Boston's Chinatown. Pak Hup is a reserved man of few words who preferred to focus on hard work and giving his children a chance at the "American dream." He has never spoken of his thirty-five years in China, the communist takeover, or the hardship he endured to come to the United States. He was a chef in a Chinese restaurant, worked his way to become a master chef, and ultimately owned his own

restaurant. He imparted his values through action—often working thirteen hours a day, seven days a week.

When you meet Pak Hup two things immediately stand out. First, he's very fit and energetic, walking tall and independently. Second, he's a noise machine! Constantly grumbling and making sounds. At first, it seems like gibberish. But he makes intense eye contact as you talk with him, and he always responds to questions—not in English or Cantonese. Just in gibberish. But gibberish that seems to make all the sense in the world to him. I asked him about being a chef, and he showed me his hands, talking away. He finally stopped talking for a second or two when his daughter Lola put her arms around him for a portrait. He couldn't communicate with her the way he wanted to—but it was enough. A warm, loving smile came across his face. A short, small moment of peace and gratitude. A small moment that meant everything. ■

CATHY SHAW

CATHY SHAW WAS RESERVED WHEN WE MET, apprehensive about the interview questions to come. That reluctance disappeared quickly, and Cathy confided that it was cathartic to talk about her experience with dementia openly because so many people did not want to listen.

Now sixty-seven, Cathy reflected back on the fear she felt in her late forties when she began to sense her mind was not functioning as it should. Several family members had suffered with Alzheimer's—her mother, aunt, uncle, an older sister—and she was terrified.

She kept her terror locked inside for a few years before finally seeing her doctor. Unfortunately, like many people with younger-onset dementia, Cathy was misdiagnosed and told she was simply depressed and should try therapy. Despite her family history, cognitive testing was not prescribed. It was not until after several frustrating years and switching doctors that she had cognitive testing and was diagnosed with dementia.

Reflecting on those first few years in her fifties, Cathy described constantly battling the stigma of Alzheimer's. Her friends refused to believe the diagnosis. People she had known for years stopped calling or would look past her when they bumped into her in town, speaking to her husband John like she wasn't even there. Cathy told me, "My group of friends was always too polite to say anything about it or ask any questions. Time after time people would tell me 'Oh, I'm just like you. I forget things too.' It used to make me so angry but now I've kind of given up. They look at me and it makes them think of their future and they look away or avoid me. Even the neurologists— when I had my recent evaluation the doctor spoke to John the entire time. Talking about me when I was sitting right there. It made me so mad!

"I'm isolating myself from my friends now . . . finally. The stress of trying to be normal and have 'appropriate' responses. It's so hard and stressful."

When I asked Cathy what her struggle has taught her, she replied, "I'm finally realizing at this age that all the worrying I've been doing all my life has been almost useless. I always thought I was preparing myself for the next thing. But now I know you can just walk up to the next thing and prepare then! Worrying is useless. I really have learned, what will be, will be."

I asked Cathy what advice she would give newly diagnosed individuals and she told me, "The best thing you can do is find a group you can join. Be part of a caregiver group or a group of others with dementia. It's so helpful to be with people who understand what you're going through. You don't feel so alone." She quickly added, "Listen. Just listen. That is all anybody needs. Don't tell them that you forget things too. Just stop and listen. And if we did that—how much kinder would life be?

"You can't fix this. And we are going to learn to be okay with it." ■

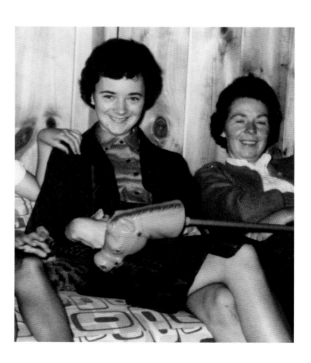

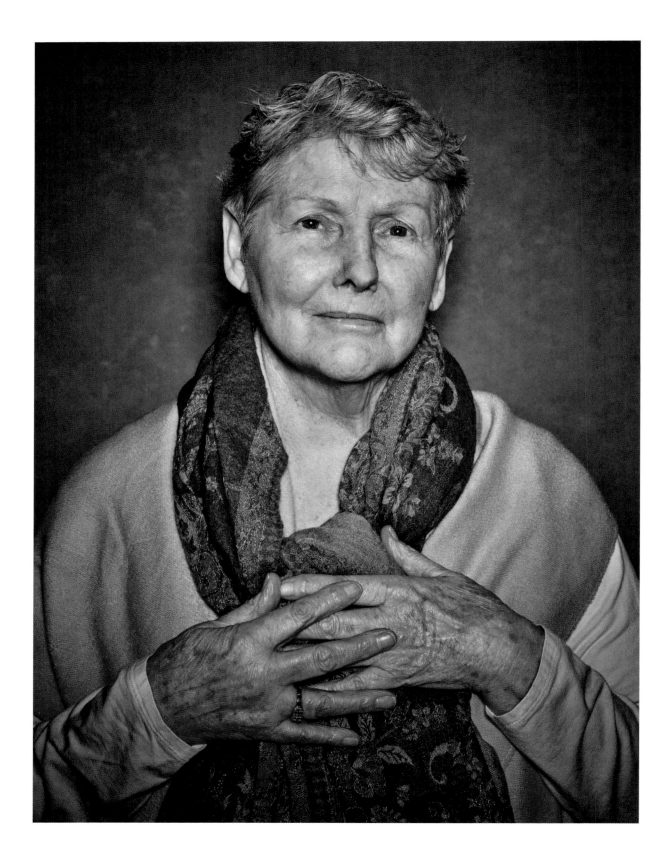

AINE WALSH

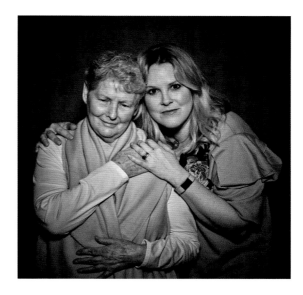

AINE WALSH WAS BORN IN 1935 IN MOYCULLEN, Ireland. Growing up on a farm with fifteen siblings, Aine dreamed of moving to America one day. Farm life didn't suit her, and she moved to Galway as soon as she was able. Eventually, Aine was able to follow some of her sisters to America and moved in with the eldest in the Jamaica Plain neighborhood of Boston.

Feeling pressure to Americanize, Aine changed her name to Anne and swore off dating Irish men.

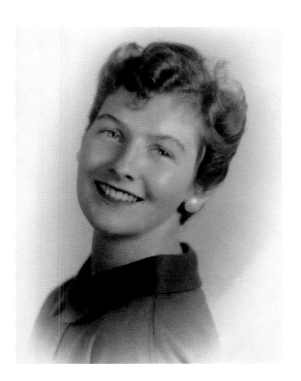

Despite her original objections, Anne met and fell in love with Edmund, a man from her small hometown thousands of miles away in Ireland. In 1962, the two strangers from Moycullen married and made their start in Lowell, Massachusetts. Anne and Edmund raised four children there and eventually retired to Cape Cod.

She loved to exercise, walk by the ocean, and shop. Anne famously took great care of herself, always dressing to impress. This passion was passed on to her youngest daughter Julie, who now runs a women's clothing store named after her mother—Aine's Boutique. As Julie explained to me—in Gaelic, Aine means radiance and beauty. I don't know any Gaelic, but after meeting Aine and her three daughters, I can't think of a more fitting name. Aine met me with her easy smile and penetrating blue eyes. We sized each other up, and she made me feel welcome from the start.

Unfortunately, Alzheimer's is a family story—five of Aine's sisters also have the disease. Staring down this family history, Aine's daughters are courageously and publicly building awareness of Alzheimer's and raising funds to help find better treatments and hopefully a cure. ∎

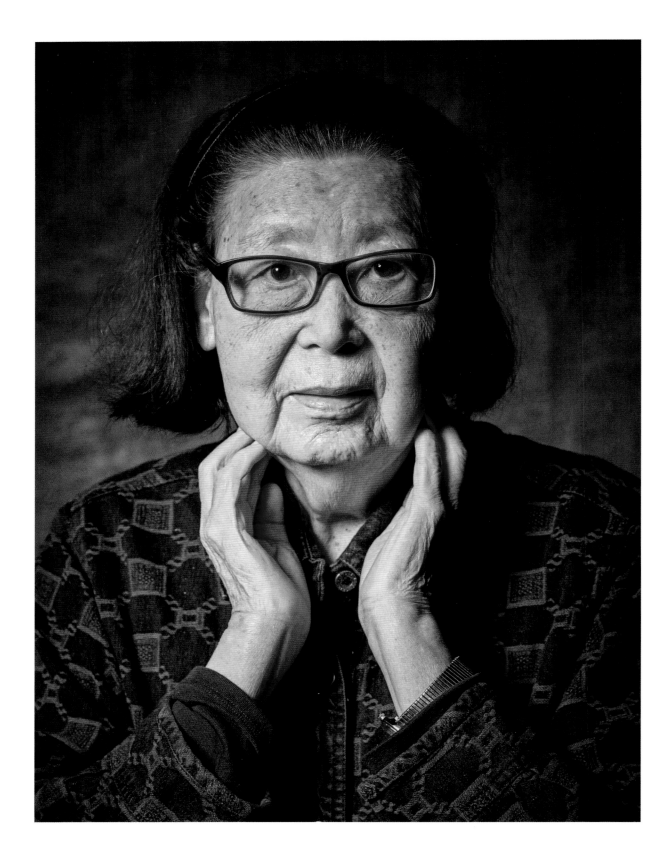

ZHIFEN WU

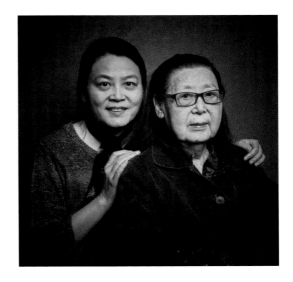

ZHIFEN WU WAS BORN IN 1937 IN BEIJING, China. She grew up in a large family that valued education and integrity. She was a college professor for many years in Xi'an. After retiring, she and her husband immigrated to the United States to be closer to their children.

Her daughter and I talked at length about the emotional hardship of caring for a parent with Alzheimer's and the struggle to find new

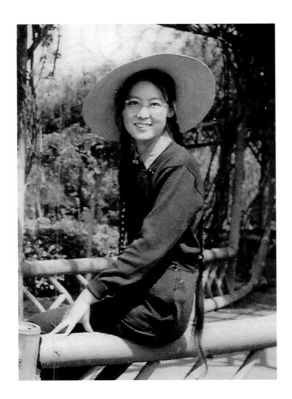

ways to love and connect, as well as the profound sense of loss and the inability to bond through shared memories.

"When you have Alzheimer's, you become a different person. When my father passed away, I could remember what he was like up until the last moment. But with my mother it's harder because that special mother-daughter relationship is no longer there. This is part of things I hesitate to talk about because when I talk about it—I feel like I have already lost my mom but she's still right here.

"I just don't know how to place my emotion. I'm not scared . . . I just hesitate. I don't know how to tell my mom's friends or my mom's relatives that she has this disease. I just don't know how to say this. She had been a very strong and independent person. Right now, I just don't see any of that.

"I want people to remember my mom the way she was. Not the way she is now." ∎

FRANCES
BASSI

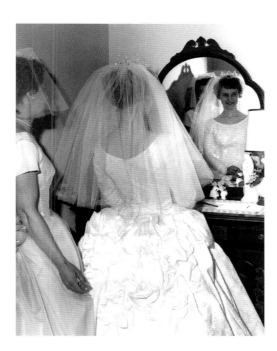

winter's day at the senior center where she and her husband, Bernie, attend support groups. One group is for those living with dementia and another group is for caregivers. They meet simultaneously so each person has the opportunity to be heard, supported, and hopefully enjoy the simple gift of camaraderie.

Fran is seventy-nine years old and was diagnosed with dementia three years ago. She has a warm smile with a sweet demeanor to match. Bernie is charismatic and direct. He is so eager to be helpful to Fran, he repeatedly answers every question directed to Fran without giving her the opportunity to speak. At one point, Bernie realizes this and apologizes to Fran for treating her like a child. Fran demurs, clearly preferring Bernie to do the talking, and says, "You're good. You're supportive."

I asked Fran what suggestions she would offer to a newly diagnosed person. After a long pause, she replied, "I don't know."

Bernie said, "I would suggest getting as much help as you can. If it gets to the point, don't be afraid to ask for help. There's a lot of organizations that will help you. We don't need it, but there is help if it gets to that point. You can ask for help. First of all, I wouldn't hide it from your family. I would suggest that you let everybody know what the problem is so that if you need help, you'll get it. I haven't thought of it much. I would strongly suggest getting a support group, because sometimes if you have a family member, they don't know how to handle it either, and they come to the support group, and they can find out what it's like and what it's going to be like.

"I would suggest to a caregiver that you have to take time for yourself. If you have a person that can't handle anything, you have to get someone to be with them so that you can have some time to yourself. I don't have that problem, because I hunt, and

I get out in the woods. I do things out in the yard, so I'm always busy, but if it ever comes to the point where I have to be with her all the time, then I have to think about, well, do I need to get somebody in to be with her for a while? I think I would strongly recommend that to anybody that's a caregiver."

I asked if Bernie had any additional advice to give caregivers, and he said, "I think before you say anything, you really, really have to stop and think about it. I'm quick. I have a quick temper. I'm Italian, so that probably explains it. You've got to stop and think. That goes along with anything in life, I think. You can never take back what you say, and once you say it, it's out there, and you could hurt somebody. In a case like that, you just have to be extra patient, which I'm not all the time, I guess."

Probing a little further, I asked "What's been the hardest part?" Bernie immediately said, "I think what's a little frustrating for me is that she doesn't have the urge to do things that she used to do."

Fran said, "I try not to think about it, that it's different."

I asked if she had anything to add, and she said, "Not much. I feel like I can still do things. I don't find it's a big problem yet. I don't know. I know what could possibly happen later if it gets worse. I don't worry about it. I don't. I'm not a worrier." ■

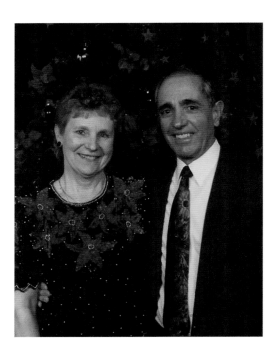

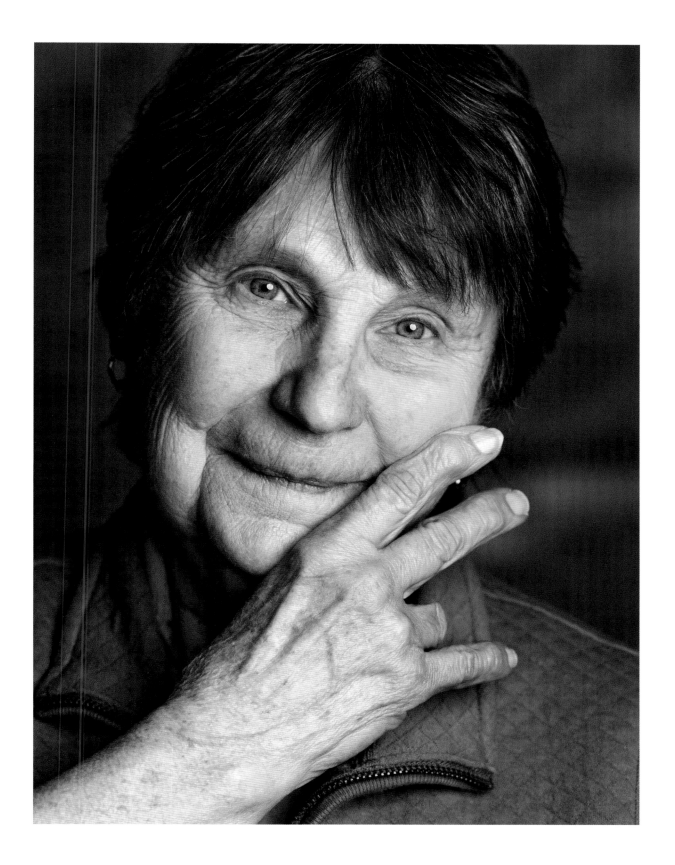

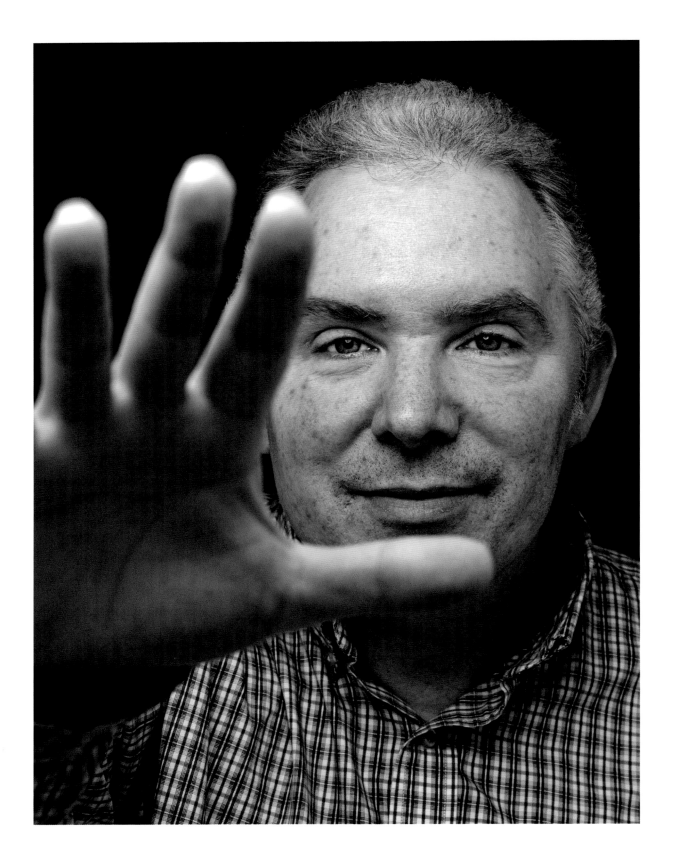

LARRY BAYLES

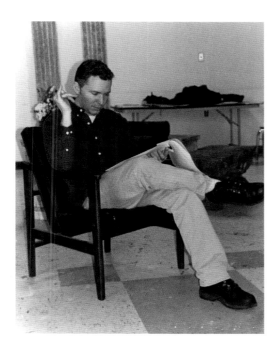

advanced Alzheimer's disease. We met at a local senior center together with his wife, Allison, and their children, Brendan (twelve) and Zooey (seven). Larry moved slowly and deliberately under the watchful eye of his family, carefully taking a seat. He had difficulty communicating but seemed to understand our conversation and waited patiently.

Allison told me Larry's father had younger-onset Alzheimer's as well and passed away at age 64, just a few months after she and Larry were married. "Larry had done neurocognitive testing. He was always very diligent, because he had that journey with his father. Even though it was in the 2000s, the way people treated folks with Alzheimer's was really different then. We had no idea. We were in our 20s and were like, 'Alzheimer's? Huh? What do we do? We don't know.'

"Larry was diagnosed with Mild Cognitive Impairment right before Zooey was born. He started to display symptoms of anxiety and depression, and there was a lot that was really difficult for me. I can talk about it now, that he hid a whole lot from me about his forgetfulness. I sometimes chalked it up to him being an artist, because he was always like that. When he got the diagnosis about cognitive impairment, it wasn't a big deal. I think part of it was denial. We didn't put two and two together that MCI is a precursor to Alzheimer's disease. No one said as much, even knowing our history.

"There were a couple of instances where he forgot his ATM code or would just keep forgetting little things. He left his checkbook or would lose his keys. He forgot to pick Brendan up one day. I didn't think too much about it, because I knew sometimes, he was really involved in his work as a teacher. He also directed shows when he was at school, just really diligent about work. Every time I would press him on something that he forgot about; I noticed a complete change in personality.

"There was a lot of aggressive behavior. Brendan can attest to this. There was a lot of yelling and screaming, and in hindsight I think it was Larry trying to mask his illness and not let me in on it. It was really, really tough having a small kid and one on the way. I look back and I was like, 'Oh, I wish I had known that to help him,' and I think he was so afraid, and the images that he has of his dad's journey with Alzheimer's . . . I hate calling it a journey because it's not really a journey. It is and it's not. It's an experience. It's a lived experience. It was really tough."

When Zooey was three, Larry lost his job teaching theater at the middle school. Allison told me, "It was a horrific experience, and we went through a really, really difficult time. Initially, after that process, Larry went into a really deep depression, and our whole family went into therapy.

"We met with someone in memory care, and they started the process of testing. They did a PET scan and found atrophy that was comparable to that of Alzheimer's disease, and then they did a spinal tap. Instead of getting a phone call, with modern-day technology, they're like, 'Oh, you have a message on your portal.' So, you log-in, and you're reading your test results essentially, and I read it,

and I was like, 'Oh, lovely, what a way to find out.' No one called. We had an appointment scheduled, but at the same time, they should have held those results instead of putting them online.

"We had this diagnosis, and it's like, 'Wow, oh, my gosh, our world is changing.' Larry continued to go through bouts of depression, anger, like rage that I had never seen before. Now that we're past those stages, I understand that it wasn't him. It was part of the illness. The children experienced a lot of that rage, thankfully, directed at me and not them. But they knew that they had to go upstairs when it happened. They would cry, maybe hide, and they still know to this day if anything happens that they call 911, and what's the main thing you're supposed to say? You have to tell the responders what?" Brendan sighed and responded, "That my dad has Alzheimer's."

Allison continued, "So it's having those conversations that are really difficult, but it's for the safety of all of us, the safety of Larry."

I asked Allison what she would like to tell families who are where she was four years ago, and she replied, "Ask for help. That was the thing, and just by nature I was the person, being the daughter of a single mom, I have this mentality that I can do it all, and it's not the case. You have to lean on people. That's something that's really difficult for me but reaching out and knowing where to go. I wish that I had known earlier about resources for our family."

I asked Allison how she would translate her family's hardship and give hope or even humor to someone else. She told me, "Larry had said something, and it was one of his language kind of things that he had. When you think about it, it was actually kind of extraordinary. We were talking about dates and times with Larry, and he said, 'Oh, it was the day after yesterday!'

"'The day after yesterday?' And I was like— 'That's today!' I think about that, and we laugh about it. 'The day after yesterday, what are you talking about?' But there's today, and every day is a new day, and I say to my kids, 'Tomorrow is never promised for any of us, so be your best self,' and they know that I say that every day when I drop them off at school as they're running out of the car. 'Remember, be kind.' I just think if we're kind to each other . . . that you never know what someone else is experiencing.'"

Zooey and I chatted about her love of theater and how she wants to follow in her father's footsteps. With prompting from her mother, Zooey nervously talked about trips to a nursing home to read to a ninety-five-year-old friend. She started to cry when Allison revealed that Zooey is now reading to her dad too. I asked Zooey what has changed at home, and she replied through her tears, "The family . . . it's kind of falling apart."

Brendan was incredibly composed and attentive throughout this conversation—he seemed to assume a great responsibility for his family. After Zooey's reply, he added, "It's like the roles have been reversed, because he showed me a bunch of things like how to turn on the TV, how to play video games, but now I'm kind of showing him how to do that, and we've been watching a lot of TV lately together. We've just been kind of helping each other out. It's nice, because I like to feel accepted and needed as any other human being would, but it's just nice to feel wanted and needed in the world."

Allison scanned the teary eyes of their children and told me, "We have good days, and we have bad days. We take one day at a time. I think all of us have learned to really live in the moment. You have to do that. You have to savor those moments. I savor the moments of clarity, whether it's every once in a while, before bed, Larry will say, 'I love you,' and it's Larry. There he is. Or he'll say, 'Thank you for taking such good care of me,' and he'll say it at a time where I just . . . where did that come from? Those are those moments that I cherish, or I see the way that he'll look at Zooey when she's playing or dancing around, or he'll enjoy a moment where we're all dancing around.

"We have something at home—we have a Joy Jar. It's to encourage those small things. We made it a point, the three of us. Brendan and Zooey and I went out and we picked out this jar, and it says 'share' on the outside. We have special papers, and you just write down, whether it's you got an A on a math test, or so-and-so made you smile. It doesn't have to be big things, it's the little things that make you smile or make you happy, and you put them in the jar. Then we can go in and pull them out and see.

"If you have a down moment, you want to go look and feel like, 'Oh, hey!' Sometimes that's what we do at our dinners. We'll open up the jar. Zooey made a thing, Family Notes, where you're supposed to write one kind thing about someone, because sometimes being siblings, they have a hard time with that. But there's a lot of things and reminders around our house that family is the key, and it's really important. Larry will put stuff down in there too in the Joy Jar, that he enjoyed reading with Zooey or we were all home together for a break playing games."

This was a particularly intense and emotional moment in our conversation, and I looked over at Larry and asked, "Is there anything you want to add or share, Larry?"

Head down, Larry slowly replied, "I guess I've been harboring a lot of guilt for having the disease, like a curse. I didn't know how to come to terms with it."

I asked, "How are you coming to terms with it?"

Larry looked at me intently and strained to speak—the words seemed ready to burst from his mouth but just wouldn't come. He hunched, defeated and frustrated, and said, "Just trying to have kind. . . . I don't know!"

Sensing his frustration, I said, "That's okay. Take your time. Do you think about your dad?"

Larry replied, "Yeah."

"What comes up for you?"

"I couldn't help him, and I know it's not rational. I couldn't do anything to help him."

I asked, "What do you want to tell your family to relieve them of that guilt that you feel? I know I'm putting you on the spot, but I'm sure you want to tell Allison probably what you wish your dad told you, right?"

Larry said, "I'm sorry to put you through this."

Allison looked at him, "I've always said you don't have to apologize, because it's not your fault." ■

RICHARD
WRIGHT

and his wife, Amy, in April of 2017. At the time, we discussed Richard growing up in Florida, and how they met in Washington, DC, and were married later in life. Richard's dementia was advanced, and he passed away in 2019. Amy and I had kept in touch, and a few months after Richard's death, I asked her if she would be willing to meet with me again and talk about her experience as his care partner.

Amy agreed to talk again and told me, "I was relieved at the diagnosis in a way because it explained a few things that were really upsetting me. I'm sure he knew—even then. He was so afraid and anxious about losing his own control, his own person-ness, his own identity. And that inevitably would show up in frustrations and anger. Once I knew he had dementia—I could let things go versus be angry and upset."

I asked Amy what was the hardest about being Richard's care partner as his dementia progressed. She paused and said, "It's hard to say, 'I can't do everything.' Even as the stress was building up. Last winter he needed 24-hour care. It's like a sick child, you can never lay the burden down. He would get up at night and fall down. He couldn't get back into bed by himself and I'm not strong enough to help him.

"I feel like I did everything I could. Last winter was just a hard winter. I wanted so much to take it through to the end. To let him die at home. And he wanted that too. But it got to be too much. He couldn't stand. He couldn't eat on his own. He couldn't help me with anything. He had to go into care. I was lucky that he went to Buckley (very close by) so I could be with him. Within three weeks he had passed."

We discussed how her experience might be helpful to others and Amy reflected, "It's so easy to lose your perspective. The loss of that partnership, that camaraderie, is hard to get past.

"It's a difficult answer but it jumps back to basic philosophy for me. It's accepting and appreciating whatever is in the moment. What you've got is what you've got. You didn't deal this hand. This is the hand that's on the table. How are you going to play it?

"For me . . . Richard washed the dishes. He did that until about a year before he died. It was what he could give. I would watch him working in the kitchen. I would appreciate that whatever he could do was amazing. The last time he did it he was just looking around . . . he was confused. And I said to him, 'Richard, is it too hard?' And he slowly said, 'Yes.' Now, younger Richard would have fought with that. He would have been angry. But new Richard couldn't remember the old Richard. So, I told him, 'You don't need to do that anymore. I'll take care of it. Don't worry about it. I've got it.' It let him be calm. It let him be reassured that somebody was going to deal with it—like a child.

"You have to readjust your whole life on the moment. Having the compassion to be empathetic with what *they're* going through. And not staying in your own ego. What do *I* want? What do *I* need? Noticing and being accepting of what's happening now. It doesn't matter what happened five years ago. You don't have to think ahead. This is what's happening right now. He can't wash dishes anymore. Yes, it was wonderful to have him wash dishes. But that's not there anymore. So, you just have to drop it off. Drop it off. All these things that you drop off one at a time. The little losses.

"It's so tempting to hold on to your ego. So, tempting to hold on to images of what you expected. And what you want. And what you think you deserve. It just wipes you right out. Here I am at the end. Saying that—I learned so much. I've learned so much. I've grown in ways that I would not have grown if I hadn't been cleaned by fire. It just burnt right through me. And it was hard. But here on the other side I have a deep peace. I've learned a lot about death and end stages. It makes me think about my own future. I'm in line. I mean, we are all going to get there and how do I want that to be for me.

"It's a deep peace of just meeting each day as the day it is." ∎

BILL
ZECKHAUSEN

BILL ZECKHAUSEN IS AN EIGHTY-THREE-YEAR-OLD pastoral minister and psychotherapist. He was first ordained as a minister and then became a therapist, working with individuals, couples, and physicians. He has dedicated his entire life to helping others.

About five years ago he started forgetting appointments and having some difficulty with life's routine tasks. Bill admits he was terrified and lived in fear for more than a year until cognitive tests confirmed his worst nightmare: he has Alzheimer's disease.

Bill worried that if he could no longer do his counseling work, he would have no contribution to make, and his life would become meaningless. He became depressed and struggled with suicidal thoughts. Bill decided to tell his son and daughter about his desire and intention to end his life. Their loving and supportive response changed the course of his depression and his plan for how to live with Alzheimer's.

His son told Bill that he understood his sadness and would support whatever decision he made. His daughter said the same and insisted on being with him for the suicide. Overwhelmed by their love and

support, Bill decided to seek help from another therapist. During those visits, Bill was reminded of his years of experience helping others with depression. He became convinced that he could still contribute and live a meaningful life—just not in the way he'd originally imagined.

Bill recognized that his fear of the disease and his self-imposed isolation for fear of telling anyone had amplified his anxiety and depression. To remedy this for himself and to help others, Bill "came out" with his Alzheimer's diagnosis publicly. He told his extended family, his work colleagues, and his congregation. He went on to write letters about living with Alzheimer's to his local newspapers and lead discussions and Alzheimer's support groups. This summer he gave a presentation with his wife of sixty-one years, Barbara, about how to live with and care for someone with the disease.

Barbara told me, "We live each day. It won't get better than today, and we try to find something interesting to do each day. It's a wonderful trip down memory lane and that's where all the best memories are at this time. We are grieving the loss of memories together," she said. "We are grieving what is to come." ∎

DOROTHY
CASTELLUCCI

THE FIFTH OF SEVEN CHILDREN, DOROTHY
Castellucci was born October 23, 1933. Dot's
father was in the navy, and she grew up in Virginia
before moving to Reading, Massachusetts. She
finished high school in Reading and spent a year at
Framingham State University where she met Joe.
Dot got pregnant and withdrew from school and
married Joe. Together they had eight children.

Joe worked as a diesel mechanic at Thomas
Ford in Beverly. Dot was fiercely independent and
wanted her "own thing"—choosing to work as a
maid at a few motor lodges in town.

Joe ventured out on his own and started a
truck repair business. Dot helped by keeping the
books and being an assistant at the shop. Together,
they ran the business for twenty-six years. Joe's
health deteriorated, and they moved in with their
youngest son, David. Soon thereafter Joe was diag-
nosed with water on the brain and passed away.

Forever wanting her independence and to pull
her own weight, Dot took a job at Toys "R" Us.
For the next fifteen years, she worked three nights
a week to earn extra money and build an IRA nest
egg that she is very proud of. Only when she broke
her hip at seventy-six did she finally quit working.

Dot continues to live with her son David, his
wife Lisa, and their seven children. David told me,
"The first thing she tells anyone is 'I have eight chil-
dren!' She is a fighter and always wants to be busy.
She is giving and hardworking."

As Dot's dementia progressed, she had a more
difficult time doing the household chores she
relished, either having physical difficulty or forget-
ting her tasks altogether. All her grandchildren
lovingly and patiently help or soothe her. David
and Lisa moved her into a first-floor bedroom, and
recently, she has become confined to a wheelchair.

I asked Dave and Lisa how they manage it all—
how they find the patience and compassion
to give so much. They both responded with calm
conviction, "Our faith is very important to us.
God tells us to take care of all widows and orphans.
We want to serve God and He commands us to do
our best."

As we ended our conversation, I considered
the love and sacrifice Dot selflessly gave her eight
children. Her faith and conviction are in no
way diminished by dementia or time. Now, her
son David and his family carry forward that faith
and conviction to selflessly give again and again.
A blessing indeed. ∎

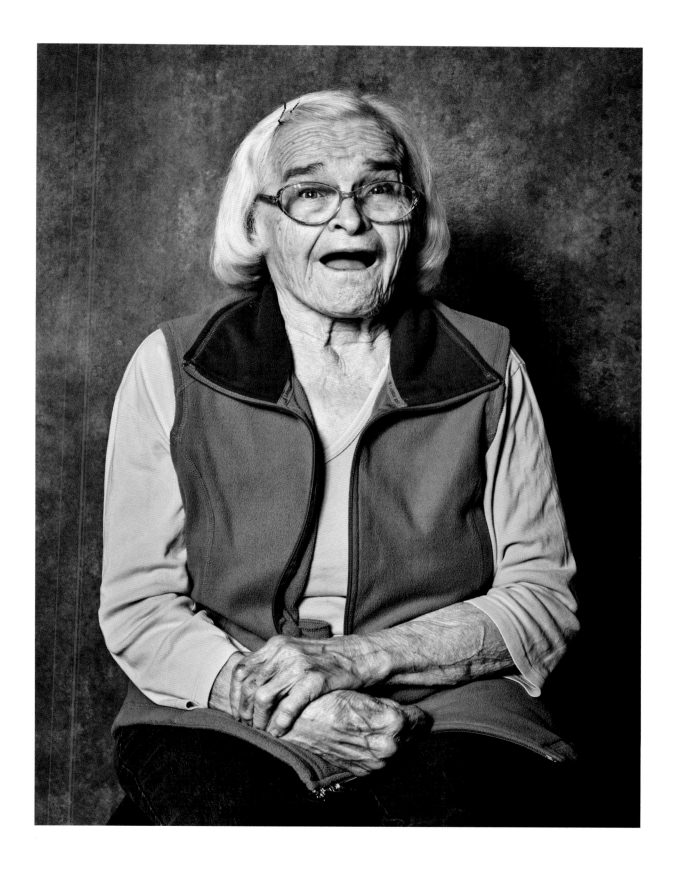

DOROTHY CASTELLUCCI | 123

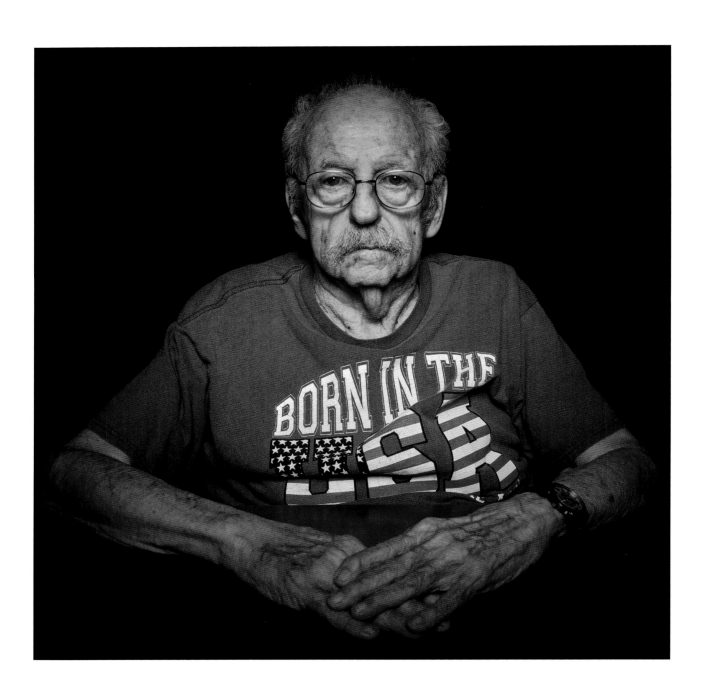

GEORGE
BLACKWELL

THIS IS GEORGE BLACKWELL. BORN IN 1925, he married at eighteen and joined the army air corps. George served during WWII as a B-24 tail gunner in the Pacific. When he returned from the war, he went to photography school and opened a studio with his wife Dorothy in Quincy, Massachusetts. George now has dementia and is confined to a wheelchair. Like many with Alzheimer's or dementia, you can't begin to properly tell the story without understanding his relationship with his caregiver—in this case, his wife and best friend.

George and Dorothy Blackwell, or "Bud and Dot" as they were known back in their youth, met on the Leominster, Massachusetts, common. Bud invited Dot to go on a bike ride that Saturday. With two friends, they rode all the way to Sterling that day (which is quite a long way). As Dot says, "We were married at eighteen and I've been holding his hand ever since—seventy-three years!"

After the war, they used the money George earned with the GI Bill to purchase a home in Quincy where they raised their two children and spent many happy years. When George retired, they lived on a sailboat traveling between Florida and the Caribbean. After a few years, they switched from sea to land and traveled North America by motorhome, finally settling in Florida. As George's dementia progressed, it became apparent that he needed full-time care in a nursing home. Dorothy agreed she and George would move to the home, but only if she was given special permission to share a room with him so they could stay together. An inspiration to many, Bud and Dot have had an incredible seventy-three years of adventures together and are continuing in the best way they can, even now. ■

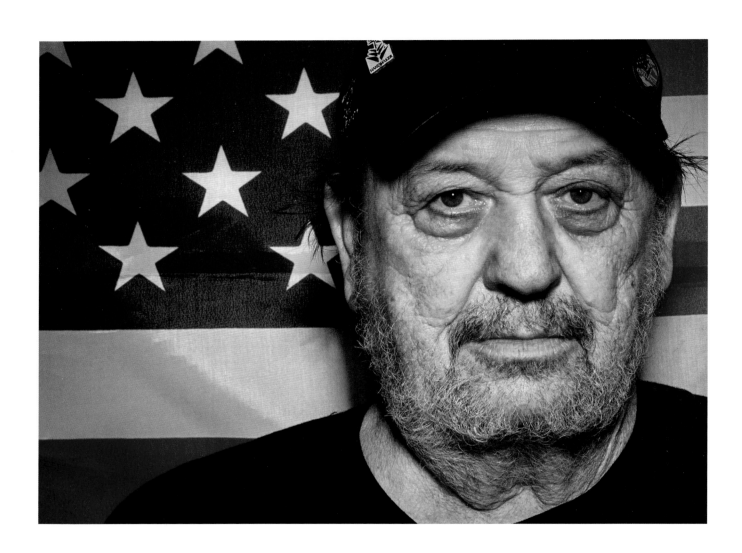

BOB LOWE

You can hear his big booming voice from across the room at the adult day-care center where we met. I was a little nervous to be introduced, but he immediately cracked a smile and was happy to chat with me.

Bob had some trouble tracking my questions but was immediately eager to share a favorite story. Bob was born in 1948 and grew up in Rockville Center, Long Island. His father worked for the phone company, and when Bob was about ten, he decided to take Bob along to work for the day. With a few other men, they drove in a big work truck to the bottom of the Manhattan bridge—a dream come true. As the men got into an elevator car, his father issued a stern warning, "Stand in the corner and do NOT move when the doors open!" When the elevator finally stopped, the doors slid open revealing a precipitous drop straight down to the East River and an incredible view of the Manhattan skyline. His dad and the other men quickly exited the car, leaving Bob inside to wait with the doors open. Thrilled and terrified, Bob sat in the corner of the open elevator not moving, waiting for his dad to return for what felt like an eternity. The men returned eventually after completing their work, and Bob returned home that night with his dad. Sixty years later, Bob relished reliving the adventure as if it were yesterday.

Bob suffers from dementia, and he had trouble answering specific questions about his past. But stories of adventures and struggles came freely, and they clearly gave Bob pleasure and a sense of belonging and purpose to tell them.

It was a poignant reminder that meaning and happiness—however fleeting—are freely available. And that for some, exacting recall of facts, dates, and specifics are not a necessity. ∎

MICHAEL
MCCORMACK

younger-onset Alzheimer's at the age of 54. He served on the Massachusetts/New Hampshire Alzheimer's Association Board of Directors and reached out to me to share his story and continue his dedication and work advocating for those living with dementia.

Michael told me, "What I tell people is— this disease does not discriminate. If Michael J. McCormack can get diagnosed at 54, in the prime of his life, without any family history, then every one of us can get this disease. It doesn't discriminate.

"This disease, if anything, for me, is frustration. Frustration that I can't do the stuff that I used to do. I tell people that I used to have an A game. It's not an A game anymore. I'm maybe a C?

"You live each day. I know I'm not going to get any better. Today is the best I'm going to be. So, you might as well enjoy it. So, if I can see that ocean every single day as much as I can, and be able to . . . it not just living . . . It's being cognitive."

I asked Michael how his wife, Diane, was coping with his Alzheimer's and he said, "She's stressed and worried. Between the job and me, she's not sleeping well. I asked her 'Diane, what can I do for you to help?' and she says 'Nothing!' I said to her 'I know you don't want to hear this but try not to worry about me as much.'

"If I get up in the middle of the night to use the bathroom—she's up because she is wondering, 'Is he coming back?' When I walk, I have to text her 'I'm walking. I'm leaving right now.' They track me on the GPS. I wear a medic alert bracelet— it says memory impaired. But I'm not at that point yet. I don't change my route. Everybody knows me down here at the beach. All the business owners. The people at the state reservation. If the cops drive by in the cruiser they stop and say, 'Hello Mr. McCormack. How are you doing today?'

"Diane is my rock. She's strong. She puts everyone else first. But I don't know how long she

can do that. I worry about burn-out for her. I said to her 'If I become a problem, you've got to move me.' If I become agitated or feisty, you know? All the stuff they tell me is supposedly coming down the pike. I told her 'Don't put up with it. You have to move me. Let someone else do it.'"

I asked, "What do you think she worries about most?"

Michael replied, "I think she worries most that she's missing time with me. She's gone nine hours a day working. I think she worries that when it's time for her to retire that I won't be cognitive enough. They told me that they want to keep me in the house as long as possible. I've seen my parents in the nursing home sitting in a wheelchair for four or five years. It's not fun. It's not pleasant. We will see how it goes. She wants us to be in our home as long as possible."

I said to Michael, "It seems like you are very motivated to give back."

He said, "For me I don't know what the future is. So if I can help one person navigate through contemplating getting a diagnosis. If we can help them through the process, to get through were we've been? Then it's all good. To get more people talking about it."

"What advice would you give someone newly diagnosed?"

"Don't change. You're still the same person. Share your story. Stay active. Get involved. Keep things positive. I know it's hard to say and do—try and stay as positive as you can. The more people that are talking about this—doesn't matter if you're living with it, if you're a caregiver—we will eliminate the stigma. But we need more conversation. To get others more serious about this disease. If you think about all the money that has been poured into this recently—why isn't there a cure or progress?"

As we walked together toward the ocean to take a few pictures together, I asked him, "What do you love about the water?"

"The water is very calming. Very peaceful. It relaxes you. Whether you're out there on a 90-degree day in the summer where it's blanket-to-blanket, or when it's in the winter and I'm the only soul on the beach. We just walk the beach. It's very soothing. Just the sound kinda puts you at ease and makes you think maybe things are going to be alright." ■

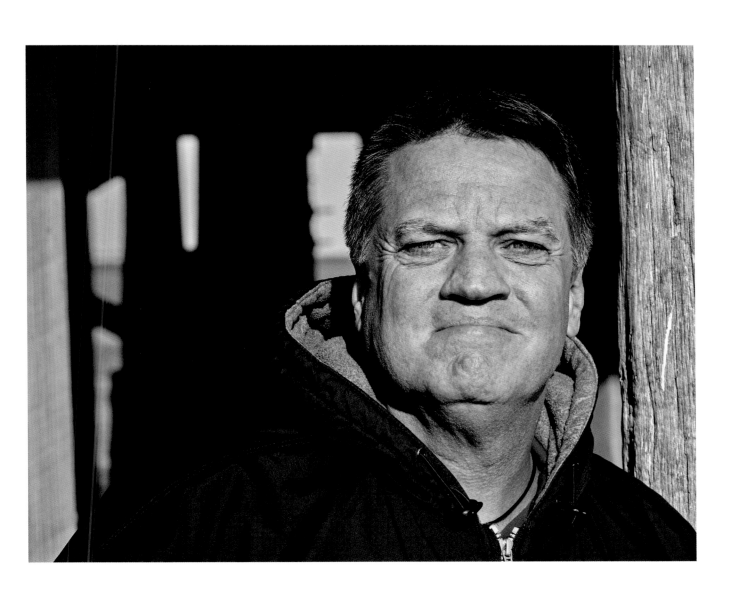

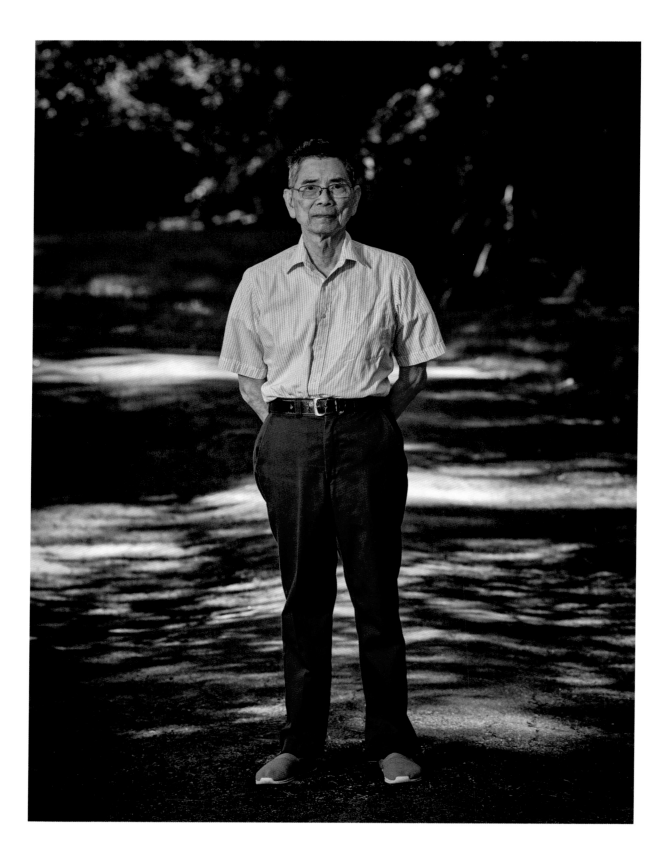

TSU-MING WU

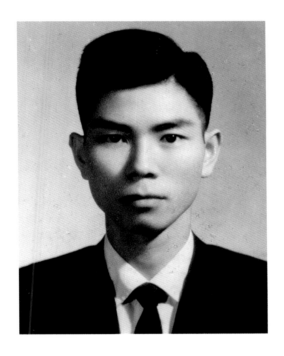

TSU-MING WU WAS BORN DECEMBER 18, 1934, in Taipei, Taiwan. One of nine children, Tsu-Ming was part of a family who took great pride in their education. He remembers the Japanese occupation and the officers who commandeered his home—but he also remembers fondly that school was closed during much of the war so he had more time for his favorite activity—fishing!

He attended the prestigious National Taiwan University and earned a degree in physics. It was there he met his future wife, Grace Chin-Fa, who was an accomplished musician. After getting engaged, Tsu-Ming traveled to the United States to study at the University of Pennsylvania. In that time, he married Grace and earned a master's degree and a PhD in physics. After two years of postdoctorate work at Case Western Reserve, he became a professor at Binghamton University, where he taught physics for forty-six years.

I asked him what was the most important thing he wanted to teach his children, and he said, "The most important for us was to keep letting them work on their education." Most of his family and siblings became doctors—a career offering

prestige and a reliable income. But Tsu-Ming chose a different path. He told me, "Making money is easy. Anyone can do that." For him, research was a higher calling, a noble pursuit of new ideas and concepts. After forty-six years of teaching and living a very modest lifestyle with few if any extravagances, he again demonstrated his beliefs by creating an endowed fellowship fund at Binghamton for graduate students in mathematics and science.

A few years ago, Tsu-Ming started showing signs of memory issues. After a few doctor's visits and tests, he was diagnosed with Alzheimer's disease. At first, he would express fear and frustration at his difficulty remembering details or doing routine tasks. Soon this was followed by diminished interest in his hobbies, conversation, and even being with family and friends. His daughter Tina told me, "He's most proud of his children and what they have accomplished. He put everything he had into us. It's very frustrating to me to see him appearing to be so bored now with his life and not be able to interact the way he used to. It really isn't fair; both my brother and I are working away in our busy 'important' jobs and large homes but can't think of durable ways to have my parents enjoy their senior years more."

Before our interview, Tina confided that they are not a demonstrative family, and I suppose a casual observer might agree. His Alzheimer's may have diminished the way Tsu-Ming communicates, his facility with language, and his attention span. But his admiration and deep love for his daughter Tina sitting across the room was readily apparent. His attention would flicker during our ninety minutes of conversation—but his smile and laughter were sparked over and over by his daughter. Look at his expression in the portrait of him alone compared to his expression when he is making physical contact with Tina. The difference is profound, and a welcome reminder that connection is possible even when you think hope is lost. ∎

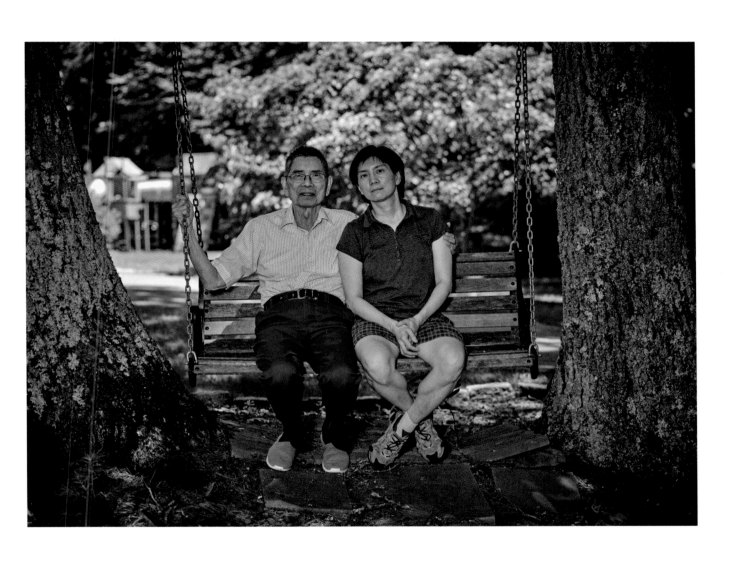

MARTHA VIOLA JORDAN

WHEN I MET MARTHA VIOLA JORDAN, I COULD immediately tell that hers was a story not easily told. Martha was in a wheelchair with her eyes closed and making expressions and sounds of anguish. I was unsure if it was the right time to talk with her and make a portrait together, but her daughter Pauline reassured me that Martha was often like this and would respond to her touch and voice. As Pauline held hands with Martha and kissed her, she offered stories about her mother and the experiences they shared.

Born in 1930, Martha and her twelve siblings grew up in Rutland, Vermont. She had several jobs over her lifetime, including home cleaner, waitress, and working at the local paper mill. She loved flowers and was active in her church. I asked Pauline about Martha's anxiety and tension and she explained that her mother had been married to a mentally and physically abusive husband her entire life. Martha's torment was amplified when two of her daughters also married abusive

men. With her dementia, Martha couldn't remember that her husband Don was dead, so she was constantly worried about what might happen next. When I asked Pauline how her mother advised her to cope with her own abusive husband—she explained that after she finally got divorced, her mom jokingly told her to "never marry that man again!" As soon as Pauline uttered these words, Martha opened her eyes wide and said, "NEVER AGAIN!!" This was the first time Martha had opened her eyes or spoken that day. It was an electric, special moment—a vibrant reminder that so much love, compassion, and connection are possible even when you think that person may be gone from you. Pauline gave her now silent mother a kiss on the forehead, and we said goodbye. A few weeks later on October 11, 2017, Martha passed away.

Martha's story is a difficult one to hear in many ways. It's a story of abuse, shattered dreams and broken promises. But it's also a story of love, perseverance and forgiveness. ■

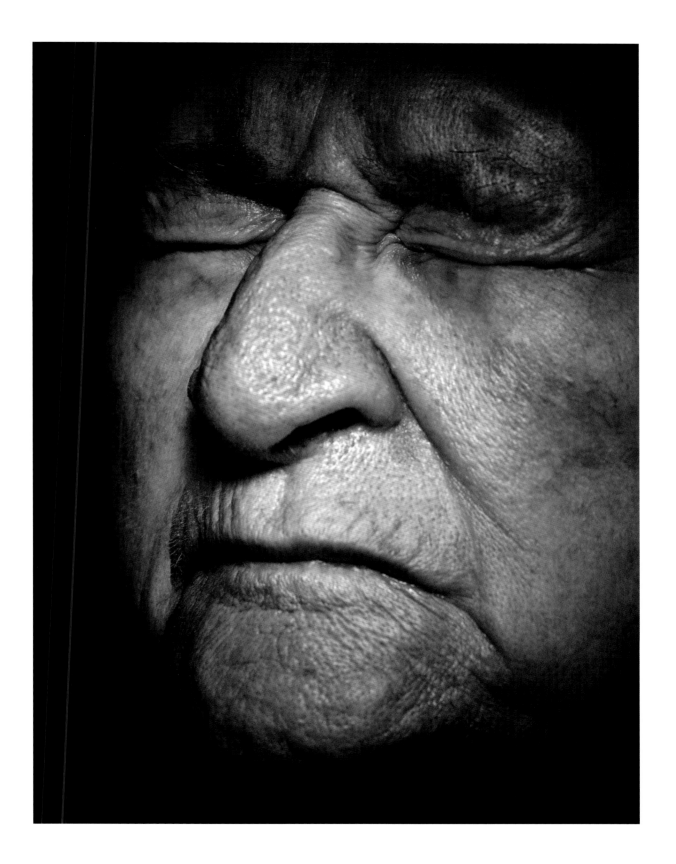

ALAN O'HARE

Massachusetts, and attended Cathedral High School before continuing on to St. John's Seminary where he studied family therapy. After leaving the seminary, Alan joined the army reserves for six years and earned an MEd from Northeastern. Dedicating himself to helping others, he was a teacher and therapist for most of his life. Alan also founded the Life Story Theater where he wrote and directed over twenty plays.

Alan is a fascinating individual who crackles with energy and warmth. He describes himself as a "Seanchie"—or traditional Celtic storyteller. Through his theater company and the expressive therapy program at Lesley University, he strove to help others find their voices. To foster courage and willingness to share the love, triumph, failure, heartache, challenge, and joy of their unique lives.

Alan was recently diagnosed with dementia, and I asked him, "Based on your years of experience as a therapist, educator, and theater director, what knowledge or understanding would you want to impart to someone else about living with dementia?"

He said, "For me it's the quote I gave you. It's the thing that keeps coming back to me because I don't always remember certain things at certain moments. 'Be patient with everything that is unsolved in your heart and try to love the questions themselves.'"

I asked him to elaborate, and he replied, "I can't get that word. I can't get that phrase. I can't get that name. It's like I don't know what's happening. So I have to take a deep breath then ask myself what's going on?

"What's going on is: I don't have access to that right now. So I take another breath. It makes me sad at times. Sometimes angry, but not so much anymore. Just sad. I know it will come back to me. I know it will be somewhere and I will have access to it again. At this moment I don't have access to it.

"So I feel like some of what's going on for me— and learning how to deal with it—and it doesn't feel

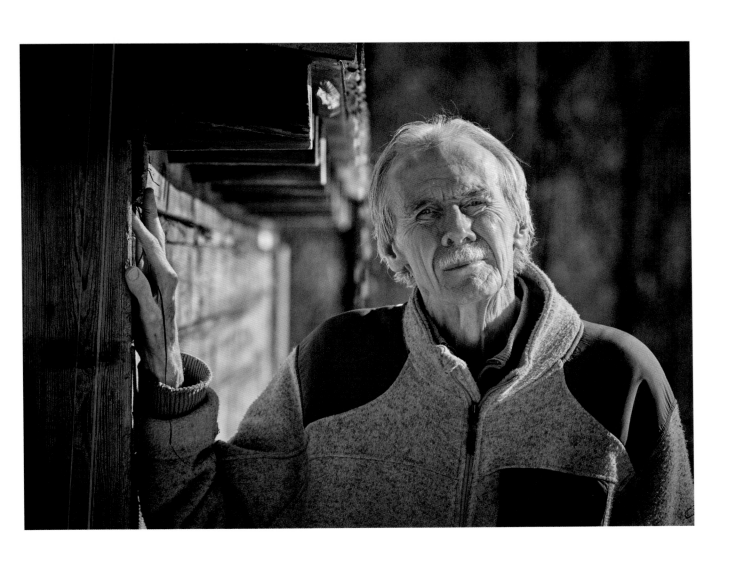

overbearing. It just feels like I'm going through a grieving state. I'm going through grieving over this part of me that I don't have access to in the way that I once had access. And I really loved that guy. I mean I really liked him.

"I think what I'm learning about me—and it comes from being a therapist, but more out of being in therapy myself—it's about being here now. What is it in this moment that you treasure? What is it about you that you treasure in this moment? Can you remember what you love about you? What do you love about right here, right now?"

Alan is a creative spark plug and continues to write and create daily. We had a long conversation about the stigma of dementia and agreed that oftentimes society will focus on the clinical diagnosis or status of an individual, which can quickly become a powerful means to distance yourself from that person and their humanity.

REFLECTIONS ON
MY FIRST EXPERIENCE
WITH INVISIBILITY

by Alan O'Hare

THERE ARE TIMES WHEN WE MEET SOMEONE we know and respect that we care for and has often been kind to us in providing services and resources, and our experiences have been usually quite positive.

There are other times we meet that same someone who is aware that we recently have lost someone close to us but are not quite sure what to say and how to say it to us. Some of the possible reasons for that are that they are not sure we would be able to fully comprehend what they are saying or that we might not be able to take it in.

One such an experience happened today with my primary care physician, a lovely, bright and friendly man with whom my son and I met earlier today for health-related issues affected by my memory loss, and learning how to manage and adapt to my new regimen of daily medications and services.

After he communicated important information about the medication-related issues, as well as exploring the data of what I'm going through, how I'm managing it, and asking me questions about what I am experiencing with these challenges . . . he then turned to my son, Chris and expressed a genuine "sorry for your loss" feeling with a subtle glance in my presence as though I had temporarily left the room, and it hurt . . . it hurt quite deeply.

I felt quite surprised by the hurt and emotional injury when he had stopped seeing me as a whole person, but only as someone with the diagnosis of memory loss related issues that will continue to unfold and increase, and to whom he will provide the necessary data and resources, all of which are quite valuable.

I then began to more fully realize as I stood at the edge of this large, ever-expanding ocean in which I am learning how to swim, sail and struggle that this too is part of this mysterious legacy that I have inherited along with millions of others in this same mysterious ocean each drifting away.

I have now become a new person in the eyes of some, including my physician, that is fading away possibly never to be seen from or heard from again, except, to quote Jack Webb from that ancient radio and TV show for "the facts, sir . . . just the facts."

How sad, how truly sad that some of us have begun to stop seeing the whole person in our new sisters and brothers entering this land in which we are now learning how to live, grow and create in a whole new way. ∎

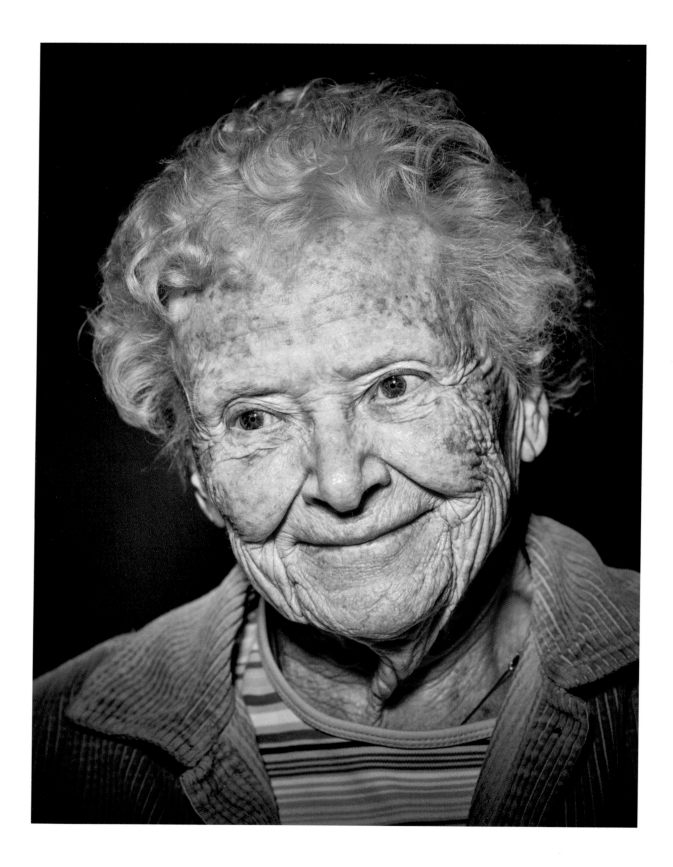

SUE BLACK

SUE BLACK WAS BORN ON JUNE 18, 1928. I could tell you about her three children; or her life in Millers Falls, Massachusetts; or the huge holiday gatherings she hosted every year; or camping by the river for the summer; or her best friend "Hot Shot," but I won't do that. Let's talk about her incredible spark instead. I knew our interview would be special from the moment she flashed her big smile and penetrating blue eyes at me. Zooming into the room behind her walker, Sue was clearly eager to break the imaginary nursing home speed limit. She didn't know who I was or why she was in the room, but she was so very alive and ready to engage with whatever we were up to. Sue calmly and patiently sat with her daughter Jaime and me for the interview. As Jaime and I talked for an hour, Sue would chime in when one detail or another sparked a memory. Sometimes an anecdote about Hot Shot or her husband, a memorable party, or "city-folk" objecting to the dog licking the icing off the cake. A particularly electric moment came when Sue and Jaime sang a favorite silly song together from many years back—filling the room and each other with elusive joy. ■

TED BLAZAK

TED BLAZAK HAS AN EASY, INFECTIOUS SMILE.
He may not remember you or some of the conversations you've shared in the past—but he will be happy to see you and greet you warmly with a firm handshake. His parents, Joseph and Helen, were hardworking Polish immigrants. When Ted was 7, his mother died of pneumonia. His dad never remarried, raising the family on his own. Ted worked hard like his father and joined the Air Force after graduating from high school. After finishing his service in Germany, he came home and worked as an engineer at United Shoe Machinery Company in Beverly, Massachusetts. Ted lost his wife to breast cancer at 55 and, like his dad, he never remarried. Soon after her death, he took a job bagging groceries at Henry's Market. He loved the work so much, he stayed for twenty years—helping people in a tangible way and being an integral part of his community. I asked his daughter what Ted taught his children about life and she said, "My dad is an honorable man. I never heard him curse. He never said anything bad about anyone. He came from nothing, but, for him, family always came first. He would tell you to have respect. Work hard and appreciate what you have." ∎

ENDING ALZHEIMER'S DISEASE IN OUR LIFETIME

By Dr. Rudolph E. Tanzi

(Modified from *The Healing Self*)

THANKS TO THE MIRACLES OF MODERN MEDICINE and the choice of so many to live healthier lifestyles, we are living longer than ever—almost eighty years on average in the United States. Yet, our health span is not keeping up with our life span, especially for that of our most precious and complex organ, the brain. For most people, the disease most feared and dreaded with advancing age is Alzheimer's disease—a quiet thief that relentlessly robs you of your memories and ultimately your very sense of self. A 2012 public opinion poll of more than 1,200 people, conducted by the Marist Institute, revealed that 44 percent claim Alzheimer's as their greatest health concern (versus 33 percent for cancer). When asked what they fear most about Alzheimer's, 68 percent cited being a burden on their families and loved ones, followed by fear of losing the memory of their lives and loved ones (32 percent).

It is hard to imagine a disease worse than Alzheimer's. We spend our entire lives, from womb to tomb, observing, learning, creating, loving, moving from one experience to the next. Over our lifetimes, these experiences shape us as individuals and sculpt our personalities. They define how we view ourselves and how our friends and loved ones "see" us as unique and special people in their lives. These experiences are recorded in the neural networks of our brain consisting of over one hundred billion nerve cells, billions of support cells called "glia," along with hundreds of trillions of nerve cell connections called "synapses."

Our neural networks record our experiences and our reactions to them, creating memories and, along with them, our subconscious fears and desires, thoughts, as well as the fodder for dreams and imagination. Everything we see, hear, touch, taste, and smell is logically placed into context with experiences of the past to continually weave a rich tapestry of neural connections and interactions that create our very personhood. Alzheimer's sneaks in like a thief in the night and insidiously begins to tear this tapestry apart, thread by thread,

until we no longer recognize our friends and family members, and ultimately, ourselves. While an Alzheimer's patient in the early to middle stages of the disease may have a relatively well-preserved long-term memory, often remembering details about their wedding day or prom night in detail, their short-term memory is devastated. This is because as sensory information is coming into the brain with every new experience, Alzheimer's patients have difficulties placing it into context and integrating it into the neural networks of their brains. As a result, it becomes increasingly difficult to keep track of that information from day to day, hour to hour, and then, minute to minute, and, in later stages, even second to second. The result is this set of symptoms (taken from the Alzheimer's Association):

1. Memory problems that disrupt activities of daily living, especially short-term memory

2. Challenges in solving problems, such as mathematical calculations in paying bills

3. Difficulty with familiar tasks, such as playing a game or following a favorite recipe

4. Confusion with time, such as seasons of months, or how to get to certain places

5. Difficulty with reading, driving, or determining distances

6. Trouble following or joining conversations, and frequent problems finding words

7. Misplacing things and finding them in odd places, like car keys in the fridge

8. Poor judgment or decision-making such as being easily conned by telemarketers

9. Withdrawal from usual activities, such as hobbies or following a local sports team

10. Becoming suspicious, paranoid, or increasingly anxious or fearful about leaving home

Dr. Alois Alzheimer first described this disease in his patient, Auguste Deter, in 1906. She was a 55-year-old woman admitted to a Bavarian asylum called Irrenschloss—"Castle of the Insane." Auguste was suffering from early onset Alzheimer's, which strikes before 60 years old. In many, if not most cases, this rare form of the disease (less than 5 percent of cases) is caused by mutations in three different genes (amyloid precursor protein, presenilin 1, presenilin 2), co-discovered by my laboratory at Massachusetts General Hospital (MGH) and Harvard Medical School in the '80s and '90s. These were the first Alzheimer's genes to be discovered and are now known to carry over three hundred different gene mutations that virtually guarantee early onset of Alzheimer's disease, usually before sixty years old.

We now know that Auguste inherited a mutation in the presenilin 1 gene, the same that was inherited by Alice in the fictional book and movie, *Still Alice*, written by my friend and Harvard colleague, Dr. Lisa Genova. In his journal, Dr. Alzheimer wrote that when he entered her room for the first time, Auguste was sitting on the side of her bed suffering from memory loss and hallucinations, which was obvious in his interview with her. He also wrote that other residents were abruptly awoken late in the night hearing Auguste crying out, "Oh God! I have lost myself!" This single description perfectly defines this horrible disease: it robs one of one's very self.

If these descriptions of Alzheimer's were not horrendous enough, Alzheimer's disease is becoming increasingly and alarmingly more prevalent, now hitting epidemic proportions in the USA and other Western countries. It's being called the "silver tsunami." There were over six million Alzheimer's patients in the USA. With every new minute, there is a new diagnosis of Alzheimer's in the USA, and if we do not come up with a way to

stop this disease, by 2050, it will increase to every thirty seconds. By eighty-five years old, one has a 30–40 percent chance of having the symptoms of Alzheimer's disease: catastrophic cognitive deficits characterized by impaired memory, reasoning, judgment, and orientation in time and space. In 2017, Alzheimer's and related dementias cost the USA an estimated $259 billion, of which Medicare and Medicaid spent an estimated $175 billion. This means that nearly one in every five Medicare dollars is spent on Alzheimer's patients. As seventy-one million baby boomers, like me, head toward the high-risk age, Alzheimer's has the potential to single-handedly collapse the US health-care system.

As we get older, we also become wiser, gentler, calmer, while others may become more agitated and irritable. In any event, there is no doubt that all of us slow down mentally as we get older. The fact is as we age, the speed with which we retrieve information and keep track of what we are doing is slowed down. The brain seems more sluggish. After fifty, we begin to have problems recalling names and words. Most of us will have "senior moments" or brain lapses. We cannot find our keys, retrieve what should be a familiar name or word, or we walk into a room and then have no idea why we went there. Losing your keys is fine—that's usually just a sign of being distracted or simply not paying attention. But, if your keys were left in your car with the car running in the garage after getting home from running errands, and absent-minded events like this happen increasingly more frequently, then there might be a need for concern about the health of your brain. It is important to know that simply having senior moments is not necessarily the beginning of Alzheimer's. However, some experts argue that it could be due to the presence of small amounts of brain pathology that begin in virtually all of us after the age of 40. As we get older, we may

all accrue some Alzheimer's pathology in our brains, similar to having a little bit of plaque around the heart, but not necessarily suffering from congestive heart failure.

Further understanding the basis of brain "resilience" to Alzheimer's disease, despite the presence of Alzheimer's pathology in the brain, requires some understanding of the exact pathology that defines this disease. The trilogy of Alzheimer's pathology includes (1) senile plaques, which are large clumps of sticky material called beta-amyloid that deposit around nerve cells in the brain (I discovered the gene that makes this toxic material in 1987 as a student at Harvard Medical School, and it is recognized as the first known Alzheimer's gene); (2) neurofibrillary tangles, which are twisted filaments that form inside of nerve cells and kill them; and (3) neuroinflammation, a response of the brain's immune system to the plaques, tangles, and dying nerve cells, which while intended to help fight infections, kills many more nerve cells by "friendly fire" or "collateral damage."

For decades, we did not know how these three pathologies link to each other. Which cause which? Which comes first? This was largely due to the early attempts to recreate Alzheimer's disease pathology and symptoms in mice. When scientists altered the genetics of mice by inserting a human gene mutation in their genome that causes early onset familial Alzheimer's disease, the mice get brain plaques but no tangles. This led to twenty years of fiery debate as to whether plaques cause tangles. All those first Alzheimer's genes that we discovered in the 1980s and '90s indicated that Alzheimer's started with plaques. Yet, this could not be proven in mouse models of the disease. The debate raged on for decades! Does amyloid cause Alzheimer's? The familial Alzheimer's genes all pointed to "yes" but the Alzheimer's mouse models said "no"! The implications of this answer for how to treat and prevent

the disease were huge! I previously wrote about this fiery debate in my book *Decoding Darkness: The Search for the Genetic Causes of Alzheimer's Disease*. At that time, the debate was still anything but resolved, but I argued that we cannot just trust results from Alzheimer's mouse models. Humans are not big mice!

Then, in 2014, my colleague Doo Yeon Kim and I decided to settle the debate once and for all. We invented what the *New York Times* would coin "Alzheimer's-in-a-Dish." This involved using stem cell technology to actually grow mini human brain organoids with early onset Alzheimer's gene mutations in Petri dishes. Miraculously, the mini-brains in the dish formed actual amyloid plaques for the first time ever, and in only four to six weeks! And, more importantly, with regard to that raging debate, two weeks after the amyloid formed, the human nerve cells were filled with toxic tangles. When we treated the brains with drugs that stopped the plaques, we also stopped the tangles.

Finally, the proof was in—amyloid indeed causes the tangles that kill the nerve cells! The mice steered us wrong! When the study was published in the prestigious scientific journal, *Nature*, no one in the field disagreed. The debate was over! Senile plaques do cause the toxic tangles that go on to kill the nerve cells. The *New York Times* called the breakthrough "groundbreaking" and "game-changing." Not only was the debate settled, but now Alzheimer's drug discovery could be achieved ten times faster and ten times cheaper than in mice. For this discovery, we were awarded the nation's highest award for innovation and invention, the Smithsonian American Ingenuity Award, and I was placed on the *TIME* magazine list of "2015 Most Influential People in the World." But the bigger challenge was ahead—how to apply this new model to actually help Alzheimer's patients. The *New York Times*'s prediction about our model accelerating

drug discovery was proven out and, even, under-estimated. Our new model made our screens for safe known drugs and natural products that could combat Alzheimer's pathology ten times faster and one hundred times cheaper. In my laboratory at MGH, we have now identified over 150 safe drugs and natural products that reduce Alzheimer's plaques, tangles, and neuroinflammation. And we are now starting clinical trials in Alzheimer's patients to test combinations of these drugs and natural products for their ability to reduce Alzheimer's pathology (with the generous support of the Cure Alzheimer's Fund, http://curealz.org).

So, what makes a person resilient to Alzheimer's? The first factor is referred to as "cognitive reserve" or "synaptic reserve." The greater the amount of knowledge one has amassed and learned (e.g., through higher education, reading, learning a new language or musical instrument, taking on new hobbies), the greater the number of synapses that are formed in the brain, strengthening the neural network. Since the degree of dementia in Alzheimer's patients correlates most closely with the loss of synapses, the more synapses you have, the more you can lose before you "lose it." So, continuing to learn new things is very important as we age. We like to say when planning for your retirement, think just as much about building your cognitive reserve as your financial reserve.

The second component of resilience was learned by studying individuals aged eighty to one hundred years old, who died with no cognitive issues, yet at autopsy revealed large numbers of plaques and tangles in their brains! What do these resilient individuals have in common? In each of these resilient brains, there was little or no evidence of neuroinflammation. Despite abundant plaques, tangles, and nerve cell death, their brains' immune systems somehow did *not* react with

inflammation. The result? No Alzheimer's disease! Just as the COVID-19 virus does not directly make you ill but instead induces inflammation that can cause organ failure, likewise, in Alzheimer's disease, the plaques and tangles must cause inflammation in the brain (neuroinflammation) to destroy enough nerve cells and synapses to cause dementia.

In 2008, my colleague, Ana Griciuc, and I discovered the first Alzheimer's gene that causes neuroinflammation. It is called CD33. We found mutations in this gene that could either increase or decrease risk for Alzheimer's by causing more or less neuroinflammation, respectively. Since that time, it turns out that mutations in genes like CD33 and dozens of other neuroinflammation-related Alzheimer's genes, such as TREM2, dramatically affect one's resilience by determining the extent of brain inflammation as plaques and tangles show up in the brain after the age of 40. As a result of these studies, many pharmaceutical companies are now developing therapies aimed at these genes to curb neuroinflammation. Such a drug would not only be useful for treating Alzheimer's but would also be helpful for other neurological diseases, such as Parkinson's disease and even the treatment of stroke.

When we put all this information together, we find that the amyloid can initiate the disease by triggering the tangles. The tangles then kill the nerve cells and spread from cell to cell, causing more tangles. As more and more plaques accumulate and increasing numbers of cells die with tangles, neuroinflammation is triggered and ten times more nerve cells die, eventually leading to dementia. So, the plaques are like a match (head injury can also act as "the match" in other forms of dementia, e.g., chronic traumatic encephalopathy in ex-NFL players or boxers), the tangles (and nerve cells they kill) are like "brushfires" spreading through the learning and memory areas of the brain. But only when this induces severe neuroinflammation, the

"forest fire," do the symptoms of cognitive decline and dementia set in.

Armed with this information, we now know that we must stop the amyloid plaques very early on. Brain imaging studies reveal that the plaques form ten to thirty years before symptoms of dementia arise. This explains why so many clinical trials targeting plaques failed. They were used on patients who already had symptoms—this was at least ten years too late. It's akin to someone having a heart attack and diagnosed with congestive heart failure and *then* deciding to only lower cholesterol levels. This had to be done at least a decade before. Using the fire analogy, it will not help to blow out the "match" once the "forest fire" is already blazing.

We can now use brain imaging and blood and spinal fluid tests to detect when amyloid plaques are first accumulating decades before symptoms and then target the amyloid as well as the tangles they trigger with anti-amyloid and anti-tangle drugs, such as those now being developed in my laboratory at MGH. This is how we will someday end Alzheimer's disease—early detection followed by early intervention, akin to managing cholesterol early in life to avoid heart disease, later on. But, for those patients who are already suffering with dementia, the blazing fire of neuroinflammation must be contained! It's too late to only target the plaques and tangles. In our own drug screens of the Alzheimer's-in-a-dish model, we have identified over sixty known drugs and natural products that "put out the fire." We have also found drugs that protect nerve cells from dying in the fire. One combination of these "neuroprotective" drugs, developed by a company I helped start called Amylyx (in which, for purposes of disclosure, I hold equity), has already led to clinical benefit in patients with amyotrophic lateral sclerosis (ALS, Lou Gehrig's disease) and

was approved for treating ALS in Canada, while we await the decision of the FDA and also test them in Alzheimer's patients. Our small phase 2 clinical trial in Alzheimer's revealed a reduction of biomarkers for amyloid, tangles, and neurodegeneration. At the end of the day, it is all about treating the "right patient with the right drug, at the right time."

Until these drugs become available, many ask, What can we do now in our own daily lives to reduce the risk of this disease as we get older? This is especially asked by those who have been found to have an increased risk for Alzheimer's disease owing to the inheritance of the genetic risk variant called APOE-epsilon 4. While this gene variant does not guarantee Alzheimer's disease, the inheritance of one copy of the APOE-epsilon 4 variant increases risk by nearly fourfold and two copies by nearly fourteenfold. So, what can one do? Based on the lifestyle recommendations made in my book *The Healing Self,* I have since derived the acronym SHIELD, as in how to SHIELD your brain from neuroinflammation and other aspects of Alzheimer's disease pathology.

1 SLEEP: **Try to get seven to eight hours of sleep per day (naps count!).** It is during the deepest stage of sleep (delta or slow wave), following dreams (REM), that the brain washes out debris like amyloid plaques. It is also when short-term memories are consolidated into long-term memories.

2 HANDLE STRESS: **Manage stress with meditation and other mindfulness techniques.** Reducing stress protects the brain from harmful neurochemicals like cortisol. In a clinical trial of meditation, we showed changes in gene expression that favor the removal of amyloid from the brain and lower inflammation. It is also worth noting that as we get older and cannot recall names and words as well, we may become increasingly and unnecessarily stressed out, getting worried about the beginnings of Alzheimer's.

Ironically, this can lead to cortisol production in the brain that kills nerve cells, perhaps, increasing the risk of Alzheimer's.

3 INTERACTION WITH OTHERS: **Stay socially engaged.** Loneliness has been confirmed as a risk factor for Alzheimer's. Social engagement and being a part of positive thinking and supporting social networks have been shown to be protective against the risk of Alzheimer's disease.

4 EXERCISE: **Perform moderate exercise or take a brisk walk for an hour every day.** During exercise, amyloid plaques are dissolved in the brain, neuroinflammation is turned down, and even new nerve stem cells are born in the area of the brain, most affected by Alzheimer's—the hippocampus, responsible for short-term memory.

5 LEARN NEW THINGS: **Build your cognitive and synaptic reserve.** Learning new things, whether it be playing a new instrument, learning a new language, brushing your teeth with the opposite hand, learning

a new commute route, or simply watching a documentary or attending a lecture, forces you to make new synapses, enhancing your cognitive reserve. Because all learning is based on associating new information with what you already know, you not only make new synapses but also reinforce the ones you already have. This also leads to new pathways for gaining access to information recorded by specific synapses and neural pathways. It is worth mentioning that crossword puzzles and brain games do not necessarily serve the same purpose as learning new things.

6 DIET: **Adopt a Mediterranean or more of a plant-based diet.** This is a diet rich in fruits, nuts, vegetables, olive oil, minimal or no red meat, and alternative sources of protein (e.g., from fish or, if you are vegetarian, like me, from legumes, tofu, and

mycoprotein from mushrooms). Plant fiber keeps the trillions of bacteria in your gut, known as your gut microbiome, healthy and happy. And when they are healthy, they help keep your brain healthy and help stave off Alzheimer's pathology.

Importantly, it is never too early or late in life to use the SHIELD plan to promote and preserve your brain health and help reduce your own risk for Alzheimer's disease.

RUDOLPH E. TANZI, PHD, is a professor of neurology and the holder of the Joseph P. and Rose F. Kennedy Endowed Chair in Neurology at Harvard University. He serves as the vice chair of neurology and director of the Genetics and Aging Research Unit at Massachusetts General Hospital. Dr. Tanzi is a pioneer in studies aimed at identifying genes of neurological disease. He co-discovered all three genes that cause early onset familial Alzheimer's disease, including the first Alzheimer's disease gene, and currently spearheads the Alzheimer's Genome Project.

ACKNOWLEDGMENTS

IT TAKES ENORMOUS COURAGE TO SHARE WITH a stranger. To trust another human with your most personal thoughts, regrets, fears, and dreams is a leap of faith. To share is to wish for the reciprocal gifts of trust, connection, and understanding. Considering I had a camera and a tape recorder, it was a leap of faith without a safety net!

I want to thank each person who spent time with me sitting for an interview and portrait. Sometimes we sat together with children, friends, or spouses. Often, we sat and talked for hours.

Over and over, I received the priceless gift of trust. Each interview is a unique and complex tapestry woven with threads of personal journey, family, community, and a determination to make the struggle with dementia less difficult for the next person diagnosed.

Taken together, these stories of *living* with dementia tell an important narrative of the human spirit. Millions of people are living with dementia all around us. Most are bravely continuing to live with love, laughter, and dignity despite the lack of a cure. A sincere thanks to each of you for helping reject the stigma of futility and despair.

I would also like to thank Liz: my wife, fan, critic, supporter, and proofreader. Thank you for being on this journey with me and sharing many late nights taking each person, family, portrait, and interview as much to heart as I did. I could not have done this without you.

Thank you, Mom. We started this work together, holding Granddaddy Joe and Bebe close in our hearts. As you have my entire life, you held me up when I thought I couldn't continue, calmly and confidently reminding me that this was important work, and if I didn't do it, no one would. You are a beacon of courage, grit, and optimism. Your relentless pursuit of personal evolution is an inspiration to me, as is your steadfast belief that I can evolve too.

Thank you, Elizabeth Chen, David Chang, Carrie Johnson, Linnea Hagberg, Emily Kearns, Andrea Burns, Jan Mutchler, Jim Hermelbracht, Marisol Amaya-Aluigi, Peggy Cahill, Heidi Levitt, Charlotte Carlo, Li Chen, Tammy Chen, Olive Fagan, Angie Garcia, Pam Macleod, Patricia McCormack, Barbara Moscowitz, Beth Soltzberg, Patty Sullivan, Amy Walsh, Molly Sonia and Tina Matz. Without your experience, help, and support, this book would simply not exist. Thank you for teaching me that listening and empathy are essential human skills and that we are all fortified by possessing them. No problem was solved with silence, and we are stronger when working together.

To everyone at the MIT Press, and especially Bob Prior, thank you for taking on this project and for taking on me. One is more difficult than the other, but we don't have to share which.

To my design partner and patient confidant, Cara Buzzell, thank you for this beautiful design and for the patience and support you generously gave me.

Thank you, Dr. Rudy Tanzi, for patiently teaching me about Alzheimer's and not judging me when I couldn't keep up. You and your work are a source of hope for so many, and I'm grateful for your help with this book.

The Dominantly Inherited Alzheimer's Network is an incredible group and source of important research. Thank you, Dr. Randy Bateman and Ellen Ziegemeier for supporting and trusting me to tell some of the DIAN participants' stories.

Thank you, John Slattery, for never failing to make me smile, laugh, and not give up. I'm eternally grateful for the introductions and the encouragement.

For showing me how much I needed a blunt critic of my self-criticism, thank you, David Shenk.

A final thanks to Martha Rappoli who started our friendship with what has become a favorite life lesson: "Life is messy. And life is beautiful that way. Just as it is. So, we don't try to force life to be neat and tidy." I try to employ this idea every single day. Thank you.

TRAINED AS A JOURNALIST, JOE WALLACE has been a portrait photographer and storyteller for twenty years. Like many, Joe has a deeply personal connection with dementia. His maternal grandfather and hero, Joe Jenkins, had Alzheimer's. His maternal grandmother Elizabeth Ponder (Bebe) had vascular dementia. And in recent years, his mother Barbara (seen here together) has begun her journey with the disease.

Joe was frustrated by the common, one-dimensional narrative of dementia—futility, despair, and loss. These are real and important elements of the dementia journey, but by focusing only on the narrowest of views, they do very little to change the stigma of those living with the disease. In many ways, showing the stereotypical perspectives only makes it easier to continue ignoring the burgeoning health crisis and the individuals themselves.

Joe feels strongly that to give the audience courage to act in ways large and small, you must show the whole story. The artist must not be afraid to show not only the fear, loss, and despair but also the love, connection, dignity, and powerful humanity that always remain—in the subjects, in the care partners, and in the families and communities. That is the only path to evolve the narrative and have a positive social change.